The Coasts of Carolina

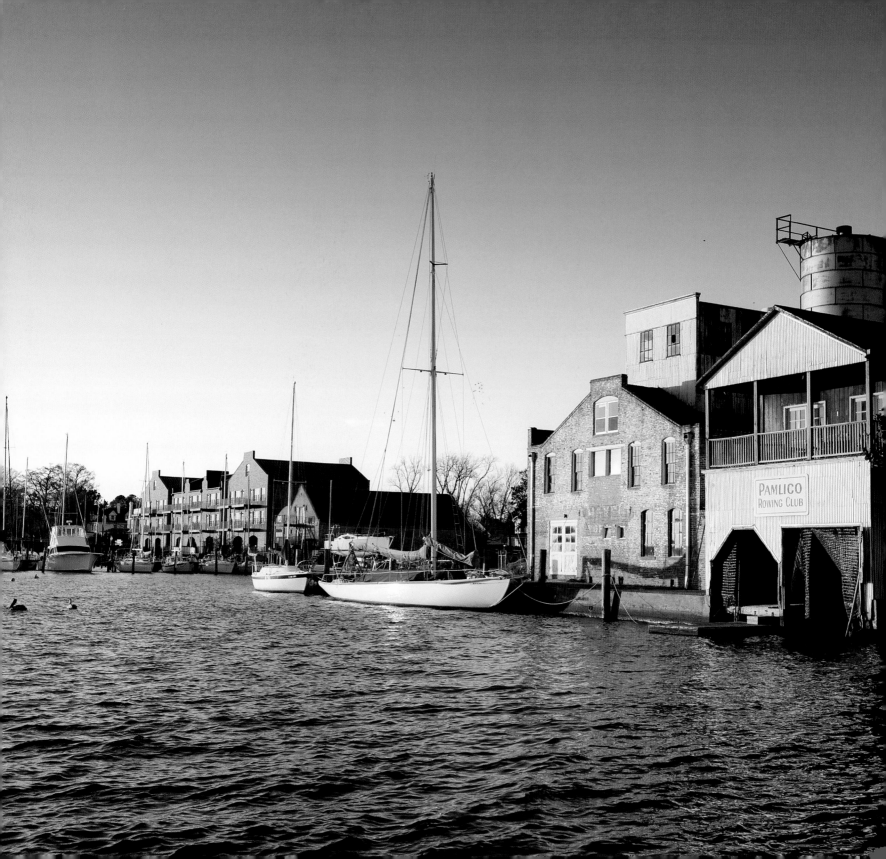

The Coasts of Carolina

SEASIDE AND SOUND COUNTRY

Bland Simpson and Scott Taylor The University of North Carolina Press Chapel Hill

This book was published with the assistance of the Blythe Family Fund of the University of North Carolina Press.

Text © 2010 BLAND SIMPSON Photographs © 2010 SCOTT TAYLOR

Library of Congress Cataloging-in-Publication Data
Simpson, Bland.
The coasts of Carolina : seaside and sound country / Bland Simpson and Scott Taylor.
p. cm. ISBN 978-0-8078-3439-8 (cloth : alk. paper)
1. Atlantic Coast (N.C.)—Description and travel. 2. North Carolina—Description and travel.
3. Atlantic Coast (N.C.)—Pictorial works. 4. North Carolina—Pictorial works. 5. Coasts—North Carolina. 6. Sounds (Geomorphology)—North Carolina. 7. Barrier islands—North Carolina.
8. Natural history—North Carolina—Atlantic Coast. 9. Fishing—North Carolina—Atlantic Coast.
10. Community life—North Carolina—Atlantic Coast. I. Taylor, Scott, 1956– II. Title.
F262.A84S56 2010 975.6′1—dc22 2010011939

14 13 12 11 10 5 4 3 2 1

For Ann, with love, and in loving memory of her mother, Patricia Cary Kindell

— **MBS III**

For Lenore, whose love and encouragement keep me on course

— **SDT**

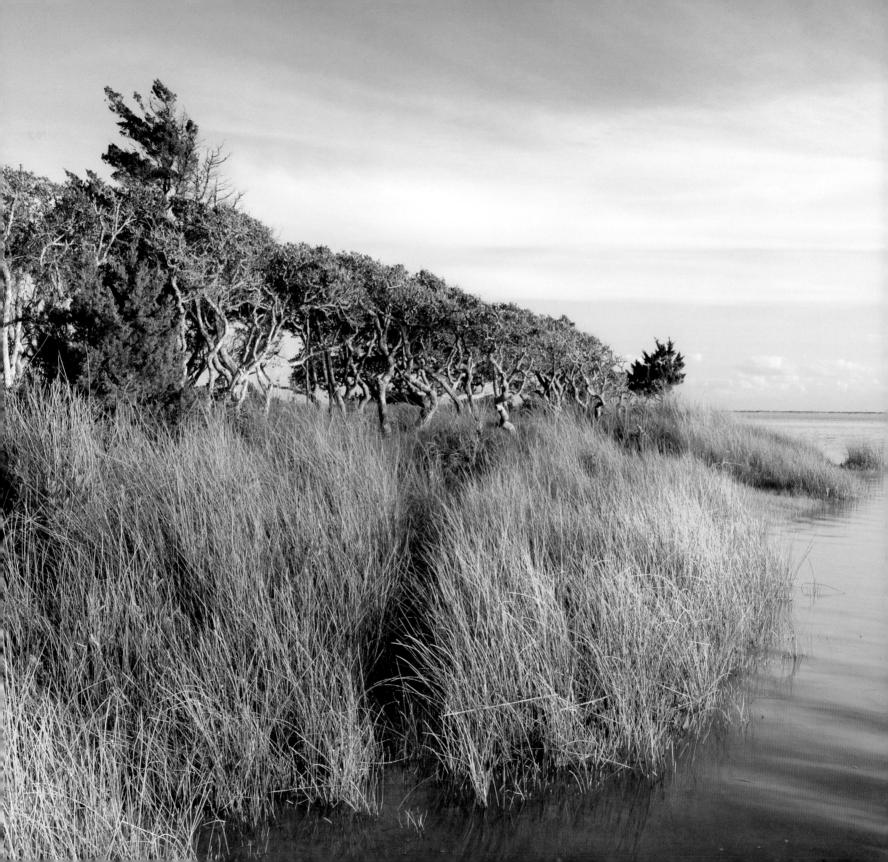

Contents

Preface

When did we two outdoorsmen first become friends and, unknowingly, future collaborators?

We met briefly during the Thanksgiving of 1987 in Beaufort, and we later had occasion to visit at the Duke Marine Lab on Pivers Island. We knew at once that our main interests were identical: the water, or many waters, of eastern North Carolina and covering this territory's many waterfronts in all their beauty, profundity, grandeur, homeliness, seductiveness, change-ability, and capriciousness, in their stark loveliness, harshness, and not infrequent danger. Natural and human histories were being enacted on seabeaches and backwaters and riverine reaches and being revealed before our eyes instantly—*constantly*—in the here and now of our own lives. If our fascination with life on these shores is deep and endless in all weathers, in all seasons, so be it.

One of us had a boat, the other a motor, and many a friendship and partnership has been engendered by just such a fact of life. Before long we were on assignment, trying to get ahold of the literal nature of Cedar Island in Down East Carteret County, of Bird Shoal on the small unnamed sound between the Town Marsh–Carrot Island system of wetlands and the barrier island of Shackleford Banks, of Huggins Island in the lower White Oak River off Swansboro. One bright January afternoon at Huggins Island we looked up and marveled when, as we slogged about in the shallows searching for antique ramparts, a man seated in what looked like a go-cart with a hang glider atop it (and at its rear a small propeller powered by a tiny engine) flew slowly over us, yet we took far more notice of this oddity than did the egrets or the pelicans all about us. We marveled even more at our difficulty in finding those old angled earth-and-

sand works, a Confederate Civil War battery that had briefly guarded Bogue Inlet back in 1861 and '62 and had long since been recovered by grapevine and sawbrier, myrtle and yaupon. The Onslow County boys once stationed there had taken its few cannon and abandoned the place without ever firing a martial shot, and what had been their small fort now looked little different from the edge of any remnant maritime woods.

If we were coastal explorers, we were also port-town men with an admittedly extravagant affection for the docks and boardwalks, the boatworks and fishhouses, the waterfront shebangs and all the waterside charms, hospitalities, and sociabilities of the communities we know up and down the coasts of Carolina, one epicenter of which is the Royal James, a shrimpburger-and-clam-chowder sporting hall on Turner Street in Beaufort that features several of the oldest and best slate pool tables in eastern Carolina, which is to say *the known world*. In this remark-able cloister, we have prayed over many a matter while shoring up our positions relative to the eight ball, from the red tide of '87 to the wreck of the menhaden-laden *Gregory Poole* near Radio Island nearly twenty years later. Here we have toasted all the boatbuilders and fishermen who know and work and love the coastal waters and, with them, hoped and prayed to the highest of high heavens that our great seacoast and estuaries might keep right on nursing and raising a plenitude of shrimp and blue crabs, spot and rockfish and flounder and trout and jumping mullet, indeed, seafood of all sorts, and for the return of our native oysters.

Tens of thousands of acres in seaside and sound country Carolina have come into public trust over the past forty years, most of it little frequented, if at all. For our travels and our time out in them, many wonders of these vast coastal areas have revealed themselves to us, and another hope we will toast at the Royal James and other oriental redoubts is that our fellow citizens—afoot, afloat, afield in any way—will ramble to coastal spots very well off the trod-den track and will come to love, or deepen their existing affections for, our vibrant, incredible commonwealth, the glorious maritime and riverine terrains and the many waters that belong to us all.

Bland Simpson and Scott Taylor
Beaufort, North Carolina
Spring 2010

Never Let Me Go

AT LARGE ON THE COASTS OF CAROLINA

Kitty Hawk, 1956

When I was a boy, my father used to take me on a warm winter's day for a very special venture in our family's maroon humpback '52 Dodge. He would drive us down to the North Carolina seacoast from Elizabeth City, our little port town on the gorgeous horseshoe bend in a dark swamp river named Pasquotank, at whose wharves steamboats once called, on whose waters a Confederate mosquito fleet failed to stop the Yankee gunboats, and where, much later, small sailing craft called mothboats first raced. Down east we drove through the immense potato-lands of Camden and across the miles-long causeway cutting through the top of the broad North River swamps, the same road we called the "turtle road" in warm weather when the sliders were sunning, and then south down the narrow, loamy, sandy peninsula that was the mainland of Currituck County till it narrowed at Point Harbor, whereupon we launched out upon the Wright Brothers Bridge across the meeting of Currituck and Albemarle Sounds and reached the Outer Banks of North Carolina.

Many of my very first memories came from this coast, and from long before the Kitty Hawk cottage that my father was now heading to work on was built or even thought of. These early recollections came from Nags Head, nine miles farther down the beach, from a cedar-shingled, seaside affair my paternal grandparents had built about 1930. From earliest childhood, out on the seabeach there, not a quarter mile from where the USS *Huron* shipwrecked in November 1877, I remember my grandmother Simpson's face and her longbill fishing cap and the coarse shelly sand and the rough deep-blue Atlantic. I don't recall her fishing or doing anything, just

My mind moves in more than one place,
In a country half-land, half-water.
—Theodore Roethke, *The Far Field*

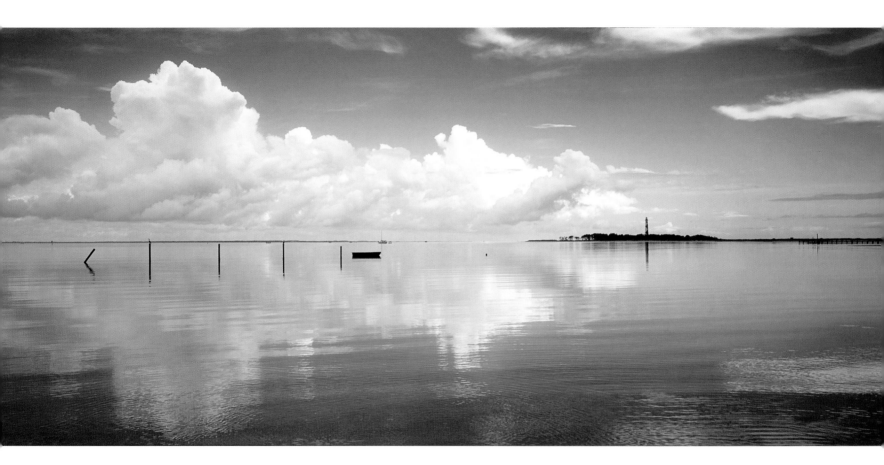

Carolina coast

that image, her stern skeptical visage beneath that jaunty sunbeater of a hat meant to buy its wearer hours of staring into the deep and trying to figure its rambunctious and wily denizens and why they were eluding the hook. And always a huge basket of blue crabs in the kitchen of that cottage and a big steaming pot on the stove—maybe I ate some, but probably not—and all those scrambling crabs, trying to get up and over the lip of that basket, out onto the floor, anywhere but into boiling water.

Now, though, we were bound for our family's small white cottage at Kitty Hawk, almost a quarter mile down the beach from a long public fishing pier, he to check the damage of hurricane winds and nor'easter storms, replace ripped and whipped-off shingles, and repair loosened

window shutters, while I, his tiny companion for the day, combed the chilled and vacant beach, bundled up and set to rambling, loving the empty strand and those 1950s wintertimes as its sole citizen.

Or sole citizen, as best I could tell.

In the tawny scurf by the sea lay marshgrass, kelp, a necklace of whelk eggs, perhaps a dull black devil's pocketbook, a piece of glass from a beer or soda bottle now so smoothed by sand and tide that its subtle green or brown color could only have come from some ethereal wonderland. Can there ever be any end to the deep and almost primal fascination we have with what has been washed up by the sea? Whatever the sea leaves has a mystical value, an unimpeachable mystique, for it is on release from Davy Jones's Locker, where all the lost things go. Never are there enough hours in the day or night or week or year for strolling the tideline and staring at what Neptune has laid before us.

Were this summertime, there would have been some jeep tracks. One reflection of the war just past were the surplus military jeeps, four-cylinder olive-drab Willys models mostly, all-time champion passagemakers that in warm weather moved fishermen and joyriding couples alike up and down this big sandbar. We children were all crazy over the jeeps when we saw them coming (beach driving being a relatively uncommon event in those days) and the passengers who waved to us and the tracks the jeeps made in the sand—this fit the insouciance of summer, the spirit of multicolored beachballs and canvas rafts and umbrellas, the easy come and go of it all.

Yet in summer there also would have been the elders, our parents and old-timers far more aged than they, coming down from cottages in the mornings and staring at the well-marked and inky tidelines left during the night, someone always making what even as a small child I knew was a serious, grim pronouncement: "The sunken ships." They meant the tankers and destroyers and torpedo boats and even sailing schooners that the German U-boats had sunk in the great battle off the Carolina coast early during World War II, lost ships that were still releasing oil, which we now saw in thin wavy lines along the coast. Those were the ships they spoke of mournfully, yet many another vessel lay in the wilderness before us, ships lost during the early explorations of the Spanish and the English, and later during the Civil War. The whereabouts of this phantom navy were far less well mapped then than now, yet I had a very strong sense of this lost world of shipwrecks and felt it was a powerful homage simply to stand there and think of it.

My father had been a U.S. Navy man himself, a lieutenant and ship's navigator during World War II, and he knew his way around boats, though it was to be quite some years before I came to understand and appreciate just how much so. In a bundle of his things sent me by my aunt long after my father's death was a captain's license he had earned at the age of eighteen, certifying him to operate fairly large craft. His longtime friend Oscar Owens once told me about a car they were always pushing and digging out of the sand roads of Dare County and about a sailboat in which they careered up and down the coast—was it sixteen feet in length, I have wondered, or thirty-six? I would never know that, nor know why one year in the 1940s while he was attending the University of North Carolina in Chapel Hill he gave as his hometown—under his photograph in the school's yearbook *Yackety Yack*—not Elizabeth City but rather Nags Head.

On the wintry Outer Banks beach of 1956, though, there was as yet none of this for me to puzzle over. Just a little in the way of oil lines, perhaps, but no elders pronouncing, no jeeps laying down tracks in the sands. Other than the surf and the sound of my father's hammer tapping away up on the cottage rooftop, things were pretty quiet. These bright fair-weather cottage-repair days and my chance to go rambling alone on the strand were a terrific liberation, and I loved it.

Being a boy and busy at it, looking down and kicking at spindrift in an effort to turn up treasures from the deep, I thought little of connections and ghosts, and had no real notion of just how much *company* I really had out on the beach on those bright cool walking days. What other phantoms were there to welcome me and walk alongside, had I but known of them? Those of the first descendants of the eastbound land-bridge pilgrims from millennia past who long ago hiked, plodded, floated, and swam their way across the continent and who at last made it to where I now stood and looked out from the last land till Africa and watched with wonder as the billows rolled in and ran like hell for something like cover back in the live-oak jungle on the strand's soundside, just as we do when the hurricanes roll up from the tropics. And then eventually the Algonquians arrived, they who came down out of the endless longleaf pine barrens and bottomland swamps and the pocosins of the coastal plains to the west and encamped for half a year at a time on such places as the south end of Roanoke Island, and wherever the oyster beds and rocks were not too far away and the firewood was plentiful. Their shell mounds and middens talk to us from a thousand years ago, or two thousand, and tell us just what a big time they

had had feasting down by the waterside. And then came Verrazano's Spaniards hailing the Indians on these shores in 1524, and the English on their first voyage over in 1584 even taking two Indians back with them (Manteo and Wanchese), and pirates like Blackbeard and Bonnet plying our unpoliced shipping lanes in 1718, and bedraggled shipwreck survivors and bold Lifesaving Servicemen of the late 1800s and early 1900s, and Coast Guardsmen after them, set in stations every eight or ten miles to tend what came in living or dead, and the men named Wright from far-off Ohio who not so very long ago came for the wind and claimed it and with linen wings and sticks and string and with a motor no bigger than a sewing machine put humankind up into the air for good, while below fishermen went on about it with nets and boats.

Though they were all now but wayward, flickering spirits, all these and so many more had once known these sands that I now strode, had seen the million diamonds of sunlight that I saw on the morning seas, the endless ribbon of moonlight on the ocean waters by night. On these winter days, besides the percussive knocking of my father's tools, no other sound reached me save that of the never-ending surf, and those hammertaps I can still hear through time like distant drumming delight. They remind me that I was no more alone then than now, and, too, they tell of my being held by a web of earth and blood, always abidingly no matter how tenuously at times, a web that could pull me back, and would, into this wide, wet, water-loving land, this land so large it was a territory, with its myriad shores yet to explore.

Covering the East, Early 1970s

For a long time thereafter I lived in North Carolina's red-clay hill country, well west of the seabeaches and swamps and sounds, and saw just glimpses of the territory a few times a year, and, during several years I spent in New York City, I hardly saw it at all. Then suddenly in 1972, more than a bit to my surprise, I made what turned out to be a twelve-gauge return to the land of the longleaf pine and the vast coastal terraces and the Sound Country and the coasts of eastern North Carolina.

New Hampshireman John Foley and I, great friends and fellow travelers that we were in those days, took off early that fall and for a solid week canoed about and camped beneath the Harvest Moon back in the cypress fastness of the Great Dismal Swamp, topping it off with a tour of nearby Mackay and Knotts Islands and their endless marshes, amazed by these great

wet plains and all the American and cattle egrets we saw there. If the small ferry across Curri-tuck Sound had been in service, we would have taken it over to Currituck Courthouse and back again, just for the ride. We were on a tear—for reasons neither of us could have named or enu-merated, we just could not get enough of low ground and lowland waters.

A month after the Great Dismal trek, my aunt called and put us to work as painters at my grandmother's cottage on the ocean at Nags Head, at milepost 11 just a quarter mile north of where the USS *Huron* had come in long ago, and so we would be down on the coast and on the job there for much of that October. A nice job too: there was not much to paint on an old-time cedar-shingled beach cottage except windows, doors, and deck, though we quickly determined that, as most of the window-lights were about to fall out of their sashes, sprucing up the old Simpson cottage would be an involving, intricate affair. As we had driven east to get there, Foley and I had first stopped and loaded up with forest-green paint at the Water Street hardware store that backed up to the Pasquotank River near the bridge in Elizabeth City (right beside where the Coast Guard had had its docks in the 1930s and President Franklin D. Roosevelt had caught the boat for Manteo to go and see the outdoor drama *The Lost Colony* on Virginia Dare's 350th birthday).

So supplied, we now hunkered down in that much-loved, well-worn family cottage and spent a couple of weeks fixing it up: reputtying those windows and slathering green everywhere except on the shingles, listening to the dry, bare porchboards suck up the thick paint, a brush-load barely making it a foot. The days were golden, and after we knocked off, we often drove out to Colington Island west of the Wright Brothers Memorial or climbed the high camelback dune of Jockey's Ridge, looking for all the best places to watch the sun go down over Albemarle Sound. We ate supper a few times at the dear, dingy old Drafty Tavern on the causeway into Manteo, fat cheeseburgers spilling out the sides of their buns or steamed shrimp and ice-cold tallboys. Back at the cottage, the fall seacoast nights were brisk and so starbright it seemed the heavens were lighting up the beach when we went out and strolled down to the Nags Head Fishing Pier and back.

In the middle of the second week things changed. A gale hit the Carolina coast, and, while we waited it out, we got inspired by the Wright Brothers and made ourselves a rather heavy kite, its crosspieces lightweight aluminum from a broken television antenna and its body an old bed-

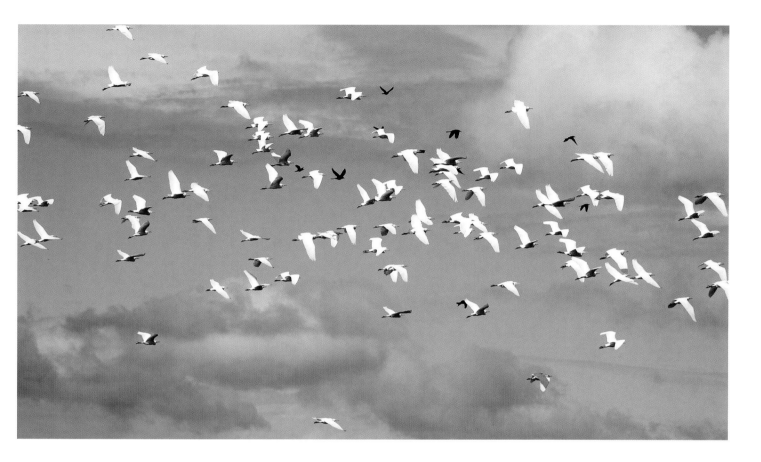

sheet. One of my cousins had told me about flying such a thing in what he called "a very high wind," and we certainly had that. We tethered the kite with strong twine, and once it went up out on the beach, one could hold it for only a minute or two before needing to hand it off. When the wind shifted around to the west, the only way the kite could fly was east, out over the ocean waves. Before long a downdraft sent it soaring down and crashing into the Atlantic—I had it in hand, and I could feel the top of its vertical strut bumping along the ocean bottom in maybe six feet of water. While I was tugging it in, the currents suddenly brought it to the surface, and when I pulled it with purpose, to our astonishment the kite righted itself, caught the wind, and rose. It crashed and sank and rose and reflew many more times before we quit, and I can still

recall those glorious flights, and how Foley and I laughed and shouted each time the kite lifted up out of the sea, saltwater spraying off it into the wind.

Early the following fall, we tore off into the Carolina east again, and this time aimed to take in as much as we could between Elizabeth City and Southport, something like the young Charley Anderson in Dos Passos's trilogy *U.S.A.*, who hopped up into a long-haul truck, just wanting "to see some country." We went roaming and checked in on a number of small scuppernong plantations—lines of vines, our sweet, popular native grape, growing on wires strung on poles, harvestable by highboy rigs that straddled them—in Pasquotank, Chowan, and Washington Counties and aiming toward the biggest such vineyard in the Coastal Plain down in Brunswick County near Southport. North Carolina had been the principal grape-growing and wine-making state in the country back in the nineteenth century—could it happen again?

Along the way we regarded trucking magnate Malcolm McLean's so-called superfarm, First Colony Farms, a great teardown and row-crop conversion that had just cleared several hundred thousand acres of pocosin, a great deal of the Albemarle and Pamlico peninsula, off the map—territory that would much later come into the public trust as the wildlife refuges of Pocosin Lakes and Alligator River. Under the blue bowl of sky, we rode the small stout cheerful ferries across the Pamlico River from Bayview to Aurora and then across the Neuse from Minnesott Beach to Cherry Point, and we went out and spent half a day ambling around Harkers Island's boatworks—watching a fellow knocking a sixteen-foot skiff together in his garage, regarding the Rose Brothers crew at work on a big flare-bow sportfisherman. After a full-dose clam-chowder-and-fried-flounder supper that evening on down the coast at Cap'n Charlie's in Swansboro, beside the broad, double-bridged White Oak River, we encamped informally, our sleeping bags beneath picnic tables in a park somewhere toward LeJeune, and were awakened by the marines' sonic-booming jet-training flights at dawn.

We crossed the New River, the shortest river in the world, they say, to be so wide. And then we went looking for ancestral haunts, my grandfather Page's homeplace in Tar Landing on the New, just a few miles upriver of Jacksonville, with no description of the old house (Granddaddy's family had cleared out for Wilmington and left the Onslow County farmstead in 1900), no directions to it whatsoever. What we found instead was Joe Powell, storekeeper of the Tar Landing Gro., who was seventy-three years old and said he could stand on his head on a basket-

ball and intended to *show* us, which he did, flipping his old self over onto his parking lot of flattened bottlecaps in the bargain. Next he showed us his fire-eating dog by lighting aflame a folded grocery bag and sailing it Frisbee-like at an eager German shepherd, which clamped its jaws upon the burning bag and batted out the fire—we smelled singed whiskers and knew it was time to peregrinate.

That night at Maco Station, on the railroad line fourteen miles west of Wilmington, we awaited the arrival of the Maco Light, the ghostly illumination that had long appeared at this spot, said to be the apparition of the brakeman Joe Baldwin, who, decapitated in a trainwreck here in 1867, kept coming back ever after and shining his lantern in hopes of finding his head. After a two-hour wait along with thirty or forty other folks, we did see a single lantern-flame light some forty or fifty yards down the track, briefly moving side to side, inscribing a couple of arcs and then sailing off and disappearing into the swamp. After considerable clamor and conjecture, the crowd thinned out, everyone wondering: Had we seen a ghost or a prank? Who knew for sure?

That was about as paranormal as it got. We hightailed it for Southport, hard by the great Cape Fear River, where the next morning we strolled about town, wondering which live oaks the writer Robert Ruark climbed when he stayed here as a boy with his grandparents, and looking in on Bomps Pancoast, master of the Old Curiosity Shop, from whom I bought a couple of sherry glasses and a flimsy rattan cane. We ambled the waterfront, stopping often and gazing out over the broad bay just inside the Cape Fear's confluence with the sea, looking out at live-oak-forested Bald Head Island and Old Baldy, its short chalky lighthouse, at tall Oak Island Light and Fort Caswell across the inlet and out on the point. My grandfather Page, I remembered, had worked at the fort as a civilian builder for two winters back during World War I—"Cold, boy, you talk about *cold*—I was never so cold in my life!" Soldiers sallied forth, he told me, to Bald Head, hunting that island's feral hogs, after which the army's spits at Caswell got busy and made holy smoke and scorched pork, and the bugle blew and rallied the troops for big barbecue feasts at the fort.

A few miles outside of Southport, we visited the forty-acre scuppernong plantation that belonged to Harry Sell Sr. and his son Harry Jr. After a lesson in postharvest pruning, we soused down on a big middle-of-the-day home-cooked meal (roasted chicken, potatoes both sweet *and*

mashed, green beans, collards and vinegar, and glasses of crackling cold, dry scuppernong wine of their own making), after which the Sells sent us on our way fully cheered and with a couple of bottles of their dry scuppernong champagne. The Sells had us feeling so charitable that we then gave a hitchhiking old codger a ride back into town, and heard all about his exploits on the job down at the fishhouse and how he rarely left the premises when things were jumping, how when he got tired he usually just lay down and took a nap on a nearby six-foot flounder. Before *he* tried to stand on his head on anything, we let him out, bade him farewell, and headed north up the west bank of the river.

Back in the Piedmont, I cobbled my scuppernong survey together for a small statewide paper called the *Carolina Financial Times*, into whose bailiwick I had sauntered some months earlier looking for work. The editors had pointed to a big map of North Carolina on the wall, the state all carved up by magic marker lines into districts, kind of like a beef chart in a butcher shop, and said they had too many writers and pretty much had it all covered, especially around Raleigh and Durham and Chapel Hill. Everything east of the fall line—the Coastal Plain and all the Sound Country and Outer Banks—was District 1, so I had pointed at it and asked: "Who you got in District 1? Who's covering the east?"

"Oh, we haven't got *any*body down *there*," they answered.

"Well, now you do," I said, and that was all there was to it. I took the beat never knowing at the time that it was both a lifetime job and the job of a lifetime.

Columbia

Columbia, that small jewel of a river port on the blackwater Scuppernong, has been the setting of my mother's family, the Spruills, for nearly 125 years now, ever since they moved to town from Alligator about 1886. For 200 years before that they lived in various places in Tyrrell County, from Colonial Beach in the west to Fort Landing in the east. No one in my immediate family has ever lived in Columbia, yet the mere mention of Tyrrell instantly conjures for me the small-arched river bridge into the little town, and the streets Main and Bridge that course past the late Victorian houses and low mercantile buildings and dead-end at the river itself.

Other images appear too: the old store tumbling in on itself at Fort Landing on the cove off the Little Alligator River fourteen miles east of town, and Willy Phillips the crabber's dock in

the cove there; the bluff at Colonial Beach with its commanding view over Bull Bay and out to Albemarle Sound, where the first of us came into this country. I can see the old Columbia movie theater downtown, where my great-uncle Phil Spruill, a timberman who'd gone blind as an adult, made his living for the rest of his days by roasting peanuts and selling them in the lobby. Fishermen like pound-netter Walter Anderson remember to this day those hot, fragrant groundnuts in their little bags. The roaster Uncle Phil used for so many years is still there in the theater, which now serves as an environmental and historical center for this section of the Sound Country.

The big cypress are mostly the stuff of legend now, and only some Atlantic white cedar, called juniper hereabouts, remain. Once I discovered an old lumber barge, all 120 feet of it, that was laid up and from long disuse had become part of the banks of the Alligator River's northwest prong. Decades-old pines are now growing up through the barge's shoreward sides, and the craft that once hauled the forest away from here is fast becoming forest itself.

Along Sawyer's Lake deep in the wilderness east of the Alligator River, though, is a stand of juniper such as Ralegh's colonists might have seen, and another, closer to Columbia, thrives in Bull Neck

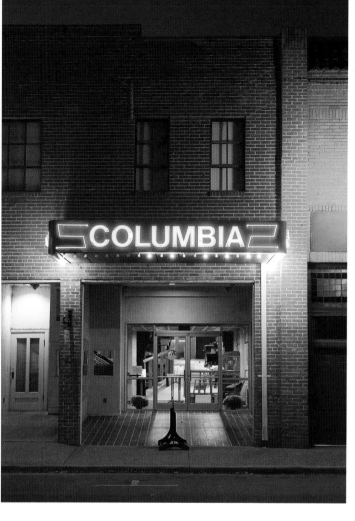

Columbia Theater, Columbia

Swamp just down the Scuppernong, over on the west side of Bull Bay. On the vernal equinox in March 2000, the people of Columbia's remarkable gallery-studio Pocosin Arts gathered at dawn to plant 7,000 junipers on a plot south of town, paying homage to the wet and water-loving land, to its people, and to the arboreal treasure that helped draw them here in the first place.

A hundred and twenty-five years ago, the bunch of Spruills who had settled onto farming grounds in east Tyrrell called Free and Easy helped a newcomer family from Maryland, immigrants named Moore who had come south for the booming timber trade. The Spruills built for the Moores a two-story frame house (which still stands) across the road from Free and Easy, and shortly afterward a Spruill son married a Moore daughter and shortly after that my grand-

mother Evelyn was born. This new Spruill-Moore family pulled up its country stakes and left Alligator for Columbia, moving into a new gingerbread home at the corner of North Broad and Bridge. My grandmother learned to ride a bicycle on the modest dirt streets of the timber and fishing town, and when her father Joseph, who had built the new home, went off to serve in the state senate in 1900, she followed him to Raleigh and attended Meredith College.

Then she came home, where she stayed and waited.

Till one autumn afternoon in November 1909, when one of her cousins asked her if she'd like to walk around the corner and take a closer look at the new brick jail just then under construction and she said yes. On the arm of her cousin Nat Meekins, Evelyn Spruill strolled into the Tyrrell jailhouse and met its builder, J. A. Page of Tar Landing in Onslow County, and fell in love. Six weeks later Mister Page and Miss Spruill were married in the parlor of that gingerbread house in Columbia, and then began some years of rambles with the building trade, to Washington, D.C., to West Virginia, to Wilmington, and finally to Chapel Hill, where Grand-daddy Page would direct the crafting of stadium, bell tower, library, and much more, and where, too, they would live in happiness together for nearly half a century.

Often they returned to Tyrrell, to kin and friends, and my mother and her siblings have long recalled for me these trips to visit the diminutive kinswoman they called Little Grandmother. From the old homeplace with all the scrollwork and sawn trim they would light off to go sailing on the sound, to go driving down to the remote landing at Gum Neck. My aunt Evelyn (of the third generation running with a girl so named in it) on these visits had as one of her afternoon assignments the duty of going downtown to the drugstore and fetching a decidedly unspiked "mint julep" to bring back to Little Grandmother, who, having retired and rested during the heat of the day, would reappear, refreshed, and sip the mint drink till supper.

Now, whenever our family is bound that way, we will take a few minutes, or hours, to stop and walk through Columbia and visit the folks we know, and just amble about knowing we are very literally striding in the steps of the ancestors and inhabiting their haunts. I am not likely to forget—nor would I ever wish to—that there is one small spot in lowland Carolina where people whose blood is now mine too have kept close company with these waters and woods for centuries. Their town, river, and county live in my heart like morning glories in a field, and open easily at the mere mention of the old names, at the slightest suggestion of home.

Hulls, 1980s

Nothing between fire and flight has so liberated us human beings as the hull.

Since my 1950s Pasquotank River outings with my father, always in a rented skiff with our little 1¼-horse Elgin outboard motor on the transom, all the small craft I had piloted were rented or borrowed, canoes mostly. This changed in the spring of 1982, when my old friend Jake Mills and I drove my Chevrolet pickup over to the south side of Raleigh and loaded up my brand-new fourteen-foot johnboat, a hull of my own.

When the maypeas were blooming in lowland gardens back in '82 and '83, we pushed it all up and down Big Flatty Creek in south Pasquotank County, on the motive strength of Jake's ever-ready and always dependable 1958 3-horse Evinrude. The cypress-fringed creek that emptied into Albemarle Sound boasted broad freshwater marshes up an interior stream on my family's old swamp timberland, here a muskrat skidding down a slide into the water, there a river otter peering at us and puffing along, and, as our fishing days warmed, now and again a cottonmouth gliding by casting a cold eye upon us.

Our camp lay at a point on the creek, the end of a long narrow lane through the big pine and gum woods, comprising a blue-and-white-striped canvas tent, an antique Coleman two-burner stove, and a couple of coolers. With three-foot banks just beyond us, we had a little elevation, and ours was a good prospect just downstream of where three small farm-country creeks flowed together and the broad brown shallow water rolled on past this wet woods my grandfather Simpson laid claim to nearly a century ago. We had an easy view of Big Flatty's opposite shore, some of it forested in cypress and pine, some open coastal Bermuda-grass pasture right down to the water where cattle grazed, their lowing muted and rolling over the broad water from almost a quarter mile away. No upstate river was anywhere near as wide as this creek.

We were there for some old-time river fishing, the slow-motion floating along just twenty or thirty feet off the banks and casting near them and up into the shadows where they were under-cut for bream, bluegills, shellcrackers, punkinseeds, white perch, and catfish. The big creek and its tributaries were quiet—we might have seen one other boat on any given day, and the only pressure on the fish of Big Flatty was whatever we applied. As darkness fell each evening (and it fell hard, for there was not a spark or ray of ambient light this far out in the country), we put together the finest creekside meals any men ever had the pleasure and privilege of sitting on

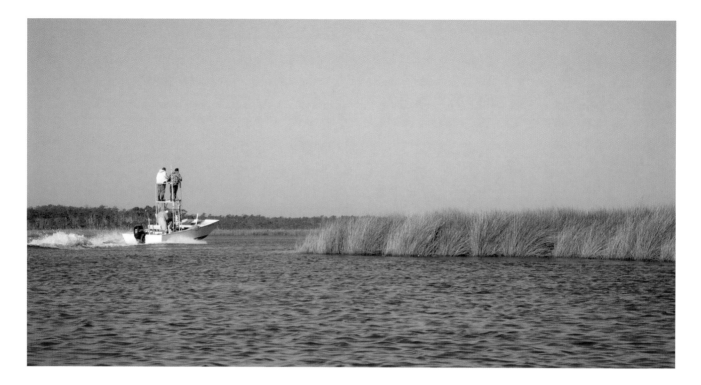

On Long Bay

a stump and eating, nicely primitive and mighty fine: hunks of bread, fried fish, sour mash. Maybe a slab of sirloin even slipped its way into the mix.

And then the springtime constellations wheeled above us, and we saw what the first folks—the Algonquians, the Tuscarora, the Nansemonds, the Coree—here on the Carolina coast saw: the Big Bear, Boötes the Herdsman, Gemini the twins, the canines large and small. On another cool May evening years later, from this same johnboat at a spot in the Newport River I would get to see another sky sculpture when, right at the ultraviolet sundown moment, the planets Mars, Mercury, and Venus appeared in an arrowlike line coming straight out of the slender, concave new moon.

The *Buddy Boat*, this wonderful little olive-drab hull, has done wonders to get me out on the many waters of the Carolina east, from Big Flatty in the northeast to the Trent River marshes above Lawson Creek and New Bern and the Neuse and the Haystacks marshes of Carteret County on the central coast, and, too, way on down the coast into the big mile-wide

marshes between Sunset Beach and the mainland in Brunswick County. Behind Sunset one evening, overexcited by being out in the creeks and listening for rails, I came cruising around a curve, ran right up on an oyster rock, and busted the shearpin in Jake's little Evinrude, though I got an easy repair the next morning at the Grissettown net shop just a few miles inland. Less than ten years later, after busting another one on yet another oyster rock, this one behind an island in the Newport above Beaufort, I pleaded my case to a young dockmaster at a high-dollar harbor nearby, his bailiwick full of overpriced, underused sail and powercraft, none of which used shearpins. He had never even heard of one ("A *what*?" he said), so I then had to beg of him the use of a bolt cutter and a nail to chop to stand in for the broken pin and power us home.

Beaufort by then had become a home and homeport to me. When Ann Cary Kindell took me to Carteret County the first time, in 1987, first to her and her mother's house, a pecan-tree-protectorate within sight of Taylors Creek, and then to her father's Core Sound coveside house at Sea Level, memory knew before knowing remembered that what she had done was bring me home in every sense. I knew it for sure when her brother Tad captained her father's twenty-one-foot fishing boat, *The Other Woman*, through the narrow, shallow cut from cove to sound, cruising easily on that calm bright warm Thanksgiving Day to first pay a call at Drum Inlet Seafood, to see the elder Willises there, and then tour the harbor at Atlantic, where Tad and Ann and their sister Carolyn reviewed the genealogy and outfitting of nearly every working craft. And though I had never laid the first eye on any of those boats before that moment, just seeing them from the water and hearing the talk—some of it certainty, some conjecture—was a fierce summons to my blood.

Though I was a long way from knowing it that first Thanksgiving on the water in Atlantic, there was an extra reason for that incredible pull, and it had to do with a hull. A decade later, I would learn of my father's having once owned a Down East classic, a forty-eight-foot, twelve-ton, two-masted, round-sterned Core Sound sharpie, the *Lucy May*, built in Smyrna in 1904. And she was not just a classic—she was a veritable *legend*, for she was *the Lucy May* that had made it through what Down East had come to be called The Royal Shoals Incident. Back in March 1929, heavy weather behind Ocracoke Inlet fell upon several Core Sound craft that were there working the oyster grounds. The *Lucy May* managed to carry her crew of three very young brothers—Victor Gaskill, 21; Clem Gaskill, 18; and Floyd Gaskill, 17—*not* to Glory but instead

(they had awakened to snow and ice in the rigging, the boat dragging anchor, and a smart northwest wind upon them) across the edge of the Mullet Shoals and past Harbor Island and behind Cedar Island, finally putting in from Core Sound at Old Man Sime's Point (so called for Simon Styron), the boys coming in over the flooded marsh, tying the *Lucy May* to a pine tree, and wading on home through the floodwaters.

Yes, *that Lucy May*. How and why had it come into my father's hands for three years way back when he was barely into his twenties during World War II and when the fate of the world hung in the balance? And how and why had it left, sailed off with one W. B. Scarboro, out of our family's life? And how had my father (while he was *well* away from the Carolina coast and off training in the navy, earning himself a saber for high marks in navigation, a blade and scabbard that was presented to him at the Long Island Yacht Club by the Duke of Windsor and that has hung upon my wall for years) gotten this boat of such size and repute into and out of our family between 1943 and 1946 (his years of ownership, said the U.S. Maritime Registry) with apparently no one else ever learning of it?

Sweet mysteries of life that such things could be—that skiffs, sharpies, schooners, all manner of hulls, whether afloat in real waters or at rest beneath them, or submerged in memory too, might yet be found and marveled over, tied off in slips or moored in harbors of refuge like Atlantic that day, or shunted up into marsh creeks, maybe going to pieces or maybe not, maybe just awaiting the hands that would come and put them to right. There was no end of revelation along these shores and in and below the waters that lapped them and in the hearts of men and women who loved them too.

Outer Banks, Late 1987

At the Cedar Island ferry slip, in the Driftwood Motel's small café, its windows tight against the Christmastide cold, Ann and I awaited the afternoon ferry, and when it finally came, we rolled aboard, along with no more than half a dozen other cars and pickups, light traffic bound north for two hours now across the sound to Ocracoke. These were old haunts, but still we were full of the sense of being bound for something new. We bundled up and stood on the foredeck in the sun, the salt air clean and astringent even, and spun crackers to the insatiable, ever-hovering gulls. Then we hid from them in our car till the ferryboat rounded the last shoals and turned in

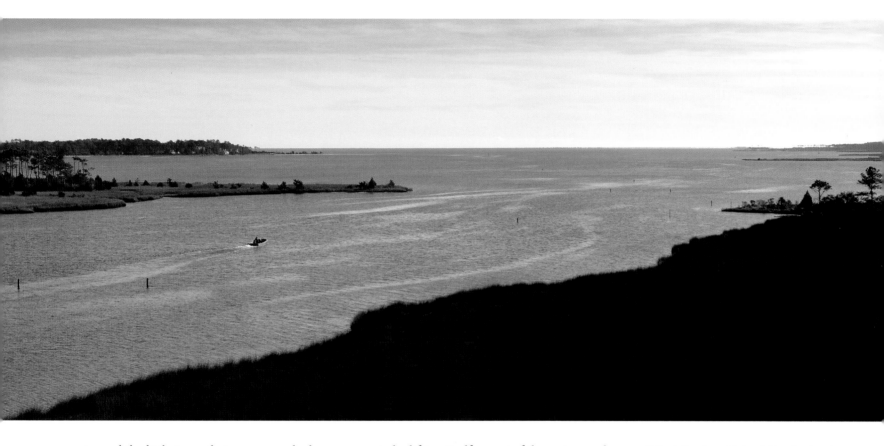

toward the little town that on approach always seems to be lifting itself up out of the waters and floating there like a village in a dream.

Salter's Creek and Nelson's Bay, Sea Level

And so might Ocracoke have been—old-time Okok and later Occacock. This winter's day, when the ferryboat shored up and moored at Silver Lake (the enclosed near-perfect circle of a harbor, town commons of this, one of the oldest settlements of our long-settled coast), Ann and I felt we'd arrived at a place aslumber, a coastal ghost town. There did not seem to be two other people in the whole frigid village. The inns that rose above the low dunes and windblown, salt-sheared live oaks were closed, and Hyde County's hoi-toiders seemed to be hibernating.

"What do you reckon?" Ann said, as we wheeled slowly through town, she as familiar with this spot as with her own home of Sea Level to the south. Often when she was eleven and

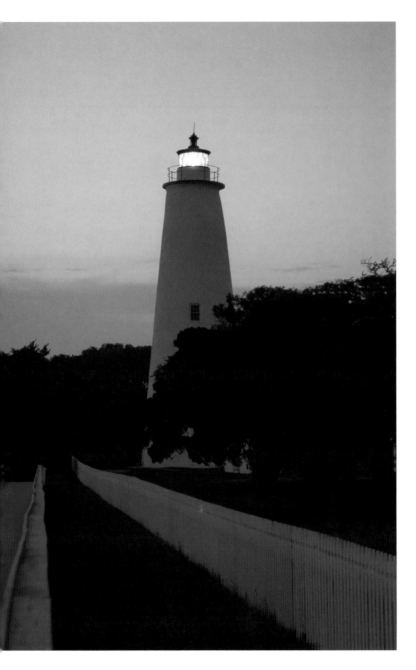

twelve, Ann and a gang of her cohorts would get dropped with their bicycles at the Cedar Island ferry in the morning and then be met when the last ferry crossed Pamlico Sound returning that night, bringing the young girls home from a day of swimming and messing around on Ocracoke Island. "You want to go on?"

"Not yet," I said, and soon we found ourselves at the point on the far side of Silver Lake. We stood shivering, bunched together on the sandy shore, watching the year's penultimate sunset over Pamlico Sound. The sky was afire on the horizon, an eggshell blue-and-green above. A long, low molten cloud, now a golden reef, in fifteen minutes became a ridge of ash. The wind, though light, was marrow-chilling nonetheless, and when a great blue heron that had been stalking the shallows scrawked and flew, we were spellbound no more.

A few lights shone here and there, and these notes of welcome drew us to the Silver Lake Motel, the last place left open on the island, this sandbar twenty miles out to sea. Inside, warming up, we ate eagerly—soda crackers, sardines, pimiento cheese—as the room heater rattled, and we listened to the marine weather radio and its talk about the tides and their times, about the bitter cold snap all along the Carolina coast.

Next day was New Year's Eve, and we ferried on up to Hatteras Island, drove north on that tenuous ribbon named N.C. 12, stopping at Pea Island to go walking on the seabeach beneath a cold sun. At Nags Head that night, in Kelly's warm, crowded, and convivial restaurant (not far from Jockey's Ridge and the Fresh Pond, places my father used to take me when I was a boy and we were out just projecting around), we found the real feast—twenty-four-count shrimp, mulled wine, thick oyster stew with flecks of fresh pepper floating in it—and the full panoply of New Year's ancient imagery. One man's uproarious

laughter kept the whole roomful in a state of high good humor, and we fell with them all into the splendid romance of the Outer Banks in midwinter, found ourselves toasting the wind, the sand, the rolling surf, having a great big old coastal time.

"Y'all newlyweds?" the waitress said.

"Ask us again," I said, "this time next year."

For the waning moments of 1987, Ann and I went to a party at a cottage back in the Nags Head Woods, that rambling of high forested sand dunes where the live oak and pine overlook so many small freshwater ponds. This was a local crowd, a couple dozen folks from Dare County mostly, and here again everyone seemed to be on the same sympathetic latitude, one Pasquotanker in the mood of the moment regaling us with tales of Sawyer, the backslid bootlegger of the Great Dismal Swamp.

At the midnight hour, we wandered out onto a deck that was snug against the dunes, and there found what we had come for, drawn without knowing why or what for, all this way up the Outer Banks. We sat alone together beneath the Full Wolf Moon's unalloyed brilliance, staring up in awe at an enormous double ring around the moon, two perfect concentric silver wheels filling the coastal night sky and rolling us imperceptibly along with them into a vast and endless future.

Honey on the Moon, January 1989

What else but the overawing great wide openness of the Sound Country, along with the old fierce pull of blood, gathered us two children of the sounds and brought us back home for a week just after our Christmas Eve wedding in 1988?

Almost without speaking of where we wished to go, to commune, to reflect on both past and future, here we were, hurtling through the flatlands with joy and purpose, the olive-drab johnboat atop our small brown station wagon, bound for Belhaven's River Forest Manor, the old timber baron's palace that as a small Pantego Creek–side hotel has greeted mariners of all stripes and ranks for six decades now with its motto: "Coil up your ropes and anchor here, till better weather doth appear."

Cold as it was afield, we soon threw ourselves into it, walking into gray and drizzly thick January mists and down a long lane of tallgrass and switch cane leading out to willows and a

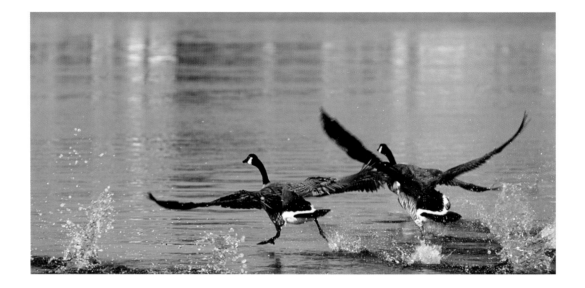

slender beach on Pungo Lake's southwestern shore. Thousands of snow geese clouded the sky low and close to the horizon, and on the lake rested more of them, along with swans, ducks, a raft of Canadas. While heading back to Belhaven, we stopped a moment to watch a comical family of otters, a quartet in a canal, puffing and blowing and snorting at us ridiculously, and nearby thousands more snow geese fed earnestly in a field bright green with winter cover and mallards by the thousands too ate whatever was left for them in corn stubble, in bean fields. The real feast, though, was all ours.

Next afternoon we put in with the johnboat at the U.S. 64 bridge at Leechville and puttered up the Pungo River, our Ted Williams 7 ½-horse engine starting even in the cold on the second pull. Upriver through golden midwinter marshes and around pine hammocks we coursed, and ere long we spied hundreds and hundreds of buzzards kettling up high into the blue ceilingless sky from sixty feet above the marsh till they simply disappeared, if darkly, in the heights, an ancient avian whorl. Their antidote we found a couple of hours later, at sunset, in the fortune of bright white swans tufted and warbling and laughing all over the waters of Lake Mattamuskeet, the Indians' "moving swamp" whose surface lies below sea level.

The fourth day found us gliding through a hundred feet or so of the cut from Kilkenny

Landing out to the upper Alligator River, where the great stream is still slender enough to sling a silver dollar over and not at all like its embayed estuarine self downriver to the north, toward its meeting with Albemarle Sound. The birds were out and about feeding while they could: a red-tailed hawk, a pileated woodpecker, robins, flickers, great blue herons, flights of redwings that did not quit, more swans and ducks, a kingfisher flying along ahead of us led by its own air-splitting trill down the short reaches of the still-narrow river, where we would soon be met by a pair of nutria on a reed-mat snug by the Alligator banks, flashing orange-toothed grins at us in welcome, or warning, who knew? Ice formed, shelved thinly, in the shadows of the riverbanks as evening came on, and we took out back at Kilkenny and drove on up to Columbia and then east to Manteo on Roanoke Island and found a room overlooking Dough Creek where its waters come down out of the marshes and find Shallowbag Bay and Roanoke Sound.

After a cold stroll on the seabeach late the next morning beyond the old Pea Island Coast Guard Station and a brace of fish sandwiches at the venerable and highly salty Sam & Omie's of South Nags Head, we drifted west and took to the eastern waters again in Bertie County, cruising the Cashie River and its hardwood bottom a few miles below Windsor. Not much flew, though resurrection fern grew all over the big gum tree branches hanging out above the river, and any midwinter green is a blessing in itself.

The sixth day we spent assaying Pembroke Creek, one of the Spanish-mossiest places in all eastern Carolina, on the western edge of Edenton, the old colonial town. We cruised far up this gray-bearded, cypress-lined creek, on up into its Pollock Swamp headwaters, and today the birds were with us again: flickers, kingfishers, cedar waxwings in flocks, a downy woodpecker, a white-headed nuthatch, a little grebe, mallards, cardinals, herring gulls, four austere blue herons like the fates plus one. Once the outboard started churning swampmud, we came about and bounded downstream and moved steadily out upon the broad, still cove that was Edenton Bay and to its opening onto Albemarle Sound.

Looking back upon the old Georgian courthouse at the head of the green, the three French cannon long ago dredged up out of the bay, now aimed fixedly out over it, and the double-piazzaed homestead, we felt as if the ancient town were floating before us, a colonial frieze. Two of the great blue herons we had passed on the way down—one in the shallows, one atop a cypress—were still in place as we cruised back upstream for the creekside landing, and

we slowed and admired them, for in spirit and aspect they were synchronous with the old town, fabulous in all their statued grace.

Six days on the inner coasts of Carolina, and we had not seen another soul, not another boat out on the water. If these were not adventures, what were they, and if we were not thoroughly alive out in the thick of them, what were we? I would gladly lean my gun on a bush, hang my watch and compass both on a branch of it, leave them, and wander off into the Sound Country's riverine jungles following this woman anytime I could. She seemed to know the way even in places she had never been before—for a few moments one afternoon that week she had leaned, laughing, into an enormous hollowed-out cypress on Lake Phelps's north shore, smiling knowingly at me as if she had just found us a new place to live, a tree roomy and comfortable enough for us to settle down in, just as the old trapper had done out on his trapline in the fastness of the Great Dismal Swamp fifty or sixty years ago.

All of this was now ours, and we took it all on home with us—Pungo Lake and River both, buzzards high over the river's marshes, swans low on Mattamuskeet, otters in the canal, nutria on the reeds of Alligator, morning sun rippling diamonds on Shallowbag Bay and soft gold on breakers at Pea Island, resurrection fern even in the Cashie's January gloaming promising spring to come, and this floating colonial dream called Edenton and its great blue sentry birds gaunt and frozen yet lovely as anything in the Louvre.

Coasts of Carolina Travels, 1990s

And then suddenly that year had passed, and we were ferrying ourselves and our twins through the great Christmas blizzard of 1989, our first goal Beaufort, where some drifts by the time we got there had made it to five or six feet and a few intrepid flatlanders brought out their cross-country skis and skied down Front Street. The day after Christmas we wended our way Down East, over the North River, where small craft were frozen atilt in river ice, past Harkers Island and Davis Island and Davis Ridge, all the slow-going way out to Ann's childhood home, Sea Level, and to the big fireplace blaze at her father's house looking out on the snow in the marsh and the forty-acre cove off Core Sound, the cold gray view eastward out across Core Sound over the light gray waters, the miles-away thin dark gray line of narrow Core Banks not only defining the horizon but being it too and beyond it nothing at all but ocean.

In those days, the very late '80s and early '90s, every three weeks or so we would leave the Piedmont on Friday afternoon and drive straightaway to Beaufort, to Ann's mother Pat Kindell's home on Orange Street, the big boxy house beneath the pecan trees next to The Cedars Inn. It never mattered what time we left upstate, for it would be dinnertime whenever we arrived in Carteret County, and as we piled into Pat's galley kitchen, an aromatic seafood dream would envelop us all, oysters and clams and shrimp with flounder or snapper or Spanish mackerel to follow. The plenitude and enthusiasm with which Pat greeted us every time made her place a Down East, down-home Eden, where children who were not even tabletop tall were, as soon as they got their coats off, reaching up over the table's edge and grabbling about for clams they couldn't even see but knew were there and knew were good.

In the summers the twins would spend hours leaping off the twenty-foot waterside dunes of Bird Shoal, down along the channel going out from Beaufort, sporting "Kid for Rent Cheap" sunvisors and doing everything sandy and watery with great vigor and glee.

Except once, during an exploration down Taylors Creek in the johnboat that led us past the old menhaden plant, Beaufort Fisheries, which is no more. Hunter lay in the bow, dabbling at the water as we pushed slowly along, but Susannah amidships suddenly shrieked, pointing as she did at the daymark another half mile ahead and yelling: "Not the Triangle, not the Triangle!" Only after I with some difficulty calmed her near-hyperventilative self down was she able to explain her hysteria: "Boats . . . disappear . . . in the Triangle . . . and never . . . come back!" And only then did her brother and I understand that for her the Sound Country daymark had become the Bermuda Triangle and we were standing directly for it and all its dangers, all its lost ships and disappeared aircraft. Crisis averted through plain talk and sweet reason, though with the sea made salty yet again by the tears of women, we beached the johnboat on Carrot Island, and for an hour or so I watched the children play in a shallow tidal pool whose very lunar-induced being was so much more compellingly mysterious—the old ebb and flood two times each day—than anything any man ever dreamt up about the Bermuda Triangle and its elusive spectres.

As these years passed we reached out and roamed all over the Coastal Plain like Coree Indians sampling encampments, now in the southeast at Big Jim Smith's 4th Street Inn near the Cape Fear River in downtown Wilmington, just across from a mossy live-oaked cemetery, the

old graveslabs in deep shadow even at noon, and near the thespian paradise of Thalian Hall, a jewel box with curved balconies that made it seem so like Ford's in Washington and that had been run, in fact, by John Ford after his own theater had been cursed by Lincoln's assassination. Or on to Bald Head Island, where we turned the twins loose with bicycles and a map one Thanksgiving time, knowing the worst that could happen would be their being momentarily turned around, while Ann and I took tiny Cary all the way to the very point of Cape Fear, the *promontorium tremendum* that the antique euphemists failed to rename as Cape Fair. I carried Cary to the end of the lazy J of land, where we stood for a time in six inches of water at the very beginning of an endless unraveling seam of currents that have played over and bathed Frying Pan Shoals forever.

Or we went the other way, to the northeast, stopping to camp on a beechwood bluff high over another mossy enclave, Merchants Millpond in swampy Gates County, where a parliament of owls exhorted each other on a full-moon April night, before getting the children on out a night later to the narrow-ribbon splendor of the Currituck Banks halfway between Duck and Corolla, where the rolling surf was aglow with phosphorescence and the moon lit up even more this hypnotic cool fire and no one could look away from it.

Yet always we returned to Carteret County, to Sea Level to visit and to Beaufort to stay. For several years Ann, the children, and I stayed a great deal in the small, old, slant-floored cottage on the water near the sunset end of Beaufort's Front Street. From its porch we had a powerful, unobstructed view of sail- and powercraft moving in and out of Taylors Creek, of the shrimpers coming in and out from their Gallants Channel wharves, of the doings over at the Pivers Island marine labs, of great freighters moving portward and seaward behind the Bird Shoal sandbanks. We could see the rolling breakers at Beaufort Inlet as they came crashing in at Fort Macon Beach, and beyond all this the huge high-piling cumulus clouds that stood so tall in the summer heavens.

Some days the twins, and later Cary too, would clamber into the eight-foot, gaff-rigged shoeboxes, the Optimist Prams, and sail away in and about the harbor of Town Creek, at the Maritime Museum's sailing school back behind Beaufort to the north. There was little else on the water that looked any gayer than ten or fifteen of these bright, tiny, light-air craft simply circling, or moving north up Gallants Channel toward the Newport River. Other times we

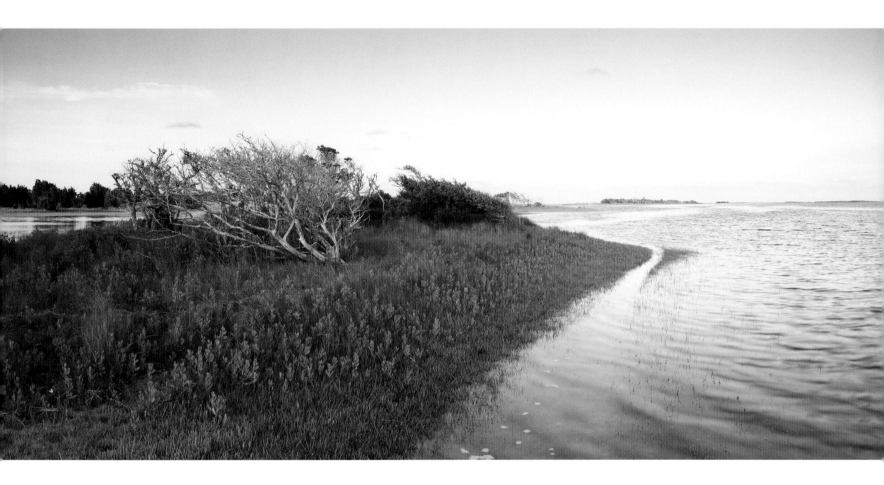

floated over in the johnboat to Town Marsh and Carrot Island and swam on the beaches there or at Bird Shoal's edge on across the broad slough beyond the cedar sandhills where the wild ponies stood or grazed or slept.

In the evenings brown pelicans and night herons came in against the reddening western skies and claimed their posts and pier-pilings, each to his own. One evening Susannah presented Ann and me with a pair of tiny ponies she had formed up and crafted out of Town Marsh's thick gray mud, adding grass seed from the cottage yard to make their tawny manes, and we have loved them and kept them and dreamed that we have ridden them all up and down

the coasts of Carolina, like the Banker ponies they represent, as if they were genuine equines and stood twelve hands high.

Bull Bay, 1997

One overcast spring Saturday—it was the first of March—I rambled down to Tyrrell and Washington Counties for another close look at those low, low lands my West Scot kinsman Godfrey Spruill came into over 310 years ago. Doctor Spruill, a surgeon in his forties, and his wife Joanna had settled on a patch of ground on the west bank of the Scuppernong River at its mouth into Bull Bay, and I wanted to boat upon the broad waters of that bay and see something of what they saw when they floated across Albemarle Sound and entered the section that is now known as Colonial Beach but in the 1690s was called simply Heart's Delight.

No small jaunty cottages were there to beckon them, no radio towers to sight on and sail toward, but of this I am certain: for four miles along the Albemarle and for nearly three miles along the western shore of Bull Bay, there was then, as there is now, an enormous swamp forest. With the state's late 1995 purchase of this stout swamp, the great wilderness joins the growing chain of public land and habitat that between Albemarle and Pamlico Sounds includes Alligator River, Lake Mattamuskeet, Pocosin Lakes, and Swanquarter National Wildlife Refuges, and now more than 5,000 acres of northeasternmost Washington County named Bull Neck Swamp.

In Columbia, my old friend David Perry and I borrowed a sixteen-foot fishing boat and set out for Bull Neck. The night before, Perry—a trout fisherman and ever-ready editor—and I had feasted at the Sunny Side Oyster Bar in Williamston on the Roanoke River, that great shoal of easternness, and, so stoked, in the center-console craft we were now plying the Scuppernong from a west-bank landing just downriver of Columbia, the county seat. We made for the sound, straight out Bull Bay, and during the half hour it took to reach the Albemarle at Laurel Point, the Saturday morning sun worked steadily at breaking through the clouds and burning off a heavy mist. When at last the big light hit the swamp woods just south of the point and illuminated them, the whole length of shoreline—suddenly saturated in spring-maple pink—was bright and breathtaking. The far coast of the sound we still saw through the mists, though closer; just a ways northeast of Laurel Point sat several dozen gulls on pilings on a ruined silver-and-rust frame out in the water. At the twisted angle iron, Perry and I came about and started

working our way down Bull Neck's shore from the point, the boat's depth-finder telling us we were cruising in only three feet of water fifty yards out.

The woods here were a mix of maple, cypress, pine, and myrtle and, as along most eroding shores, held out no shortage of dead trees akimbo, and with their bark sloughed off. An occasional crab-pot bobbed in water that was easy, almost slack, and now the sunlight in regular waves fell over the forest and sparkled on Bull Bay. We got off the shoal that stretched out from the point, and then, when we were showing nine feet of water forty yards out, Perry and I turned and went on in, landing the boat amid the stumps and waterlogged root-tangles, the wooden boneyard of Bull Neck's sandy beach.

We ambled up and over the narrow baybeach's primary—and only—dune, a rise of perhaps a couple of feet that then rolled off, down, and away immediately into the muddy bottom of Bull Neck Swamp. In knee-high rubber boots we walked about for a spell in the swamp, a cutover woods grown up now very much in maple just like its larger, near-northern neighbor, the Great Dismal. The air is frequently still and close in such places, and after a bit, Carolina-mountain-born David Perry smiled and shook his head before we headed back through the sucking muck for the little beach, passing judgment: "It's quite . . . *claustrophobic* in there."

A winter's wave had set a twelve-foot plank neatly across the fallen trees like a bench, and I sat upon it for a while just enjoying this bright day that the first of March had become, the blue sky above bay and sound and another Carolina spring coming on. An old thin-slat bushel basket lay there on the beach, and I had heard four or five loud woodpecker chops when we first landed. Something is always eating away at wood, I thought, weathering it, taking it to task somehow. A woodpecker-gnawed tree hung at a ten-degree tilt out in the water, and the little bay waves splashed over the root-tangles and hit the hollows of waterlogged trees, making deep, questioning sounds as bullfrogs do.

What would become of Bull Neck? All the tree stumps in the shallows undoubtedly marked where dry land had been till wind and waves and the sea's rise over time reshaped the shore, moving it back several hundred feet since European settlement. The sandy strand itself was no more than twenty feet wide, and the big bottom beyond could not have been two feet above the level of the bay—if that. For now the thin span of sand seemed just enough of a topo-presence to protect the vast swamp muckily consolidated behind it, though rising water levels and the

ferocity of erosive nor'easters could move Bull Bay, and Albemarle Sound, right in on Bull Neck Swamp someday soon.

But not this day. Perry and I spun the boat around and plied for deeper water, seeing spires of juniper and tall pines now in the waterside woods, clearer beach and more cypress too as we chugged back up the bay. A small-craft advisory for this particular marine territory: an enormous shoal broadens out from the more northerly of two prominent points here on the west side of Bull Bay and takes up much of the underwater real estate down to the lower point, near which daymarks signal one away from the shallows and into the mouth of Deep Creek.

Here in the quarter-mile cove leading into the dark and narrow creek were some of the loveliest of Bull Neck's natural features, several small islands—some marsh, some wooded—and an incredibly mossy cypress forest all along the water's edge. Ospreys circled above us, and we wandered up a branch, spooking a few sunning turtles off their logs and marveling at the hanks and cascades of Spanish moss—all the bed-stuffing in the world seemed to be hanging in the trees at Deep Creek's mouth.

Not far up the creek itself, on the north bank, lay the frame of an old landing where barges that bore the big cypress and juniper woods away once lay up and loaded, for the forest fell here in 1917 and '18, again in the 1940s, and yet again in the 1980s. These stout timbers ran perpendicular to the creek bank for forty yards or so, with a few still lying across them in a grid. A slider sunned here too, and some of the old supports now served the forest in a different way: young three- and four-foot pines had rooted in the waterside timbers and were growing up out of them. To the north, I knew, over a thousand acres had sprung forth again in juniper, and, at least in part, the new woods would more and more resemble the old.

It was a good cruise, a gliding view of the bayside and creek bordering the state's new holding. On the way back upriver toward Columbia, Perry spotted a bald eagle in the treetops of the Scuppernong River's eastern shore, perhaps one of the pair recently found nesting in a tall dead pine near Bull Neck's center. At our landing, a friendly, open-faced fellow wearing a feed-store cap was fixing to launch his sparkling blue bass boat, and, after saying he was just getting the boat out to go for the first ride of the season, he asked us with a broad springtime grin: "Didn't catch 'em all, did you?"

Then it was early September, and I went back to Bull Neck on a day that had dawned rainy

and miserably misted up in the Piedmont, but that mystically started to clear about the time I stopped at Shaw's BBQ in Williamston for two sandwiches—with slaw—to go. That Wednesday became a glorious Coastal Plain Indian summer day, farmers cutting corn everywhere and cotton and crepe myrtle and goldenrod all in flower. I drove for the Y east of Roper, north toward the sound bridge, then east on Pea Ridge Road, its ditches all full of water, to the purple-and-white painted tractor tire that marked the turn onto Spruill Road.

This time at Bull Neck I was alone, and on foot.

I left my jeep on the south side of Deep Creek, at the sandy landing beside the wooden plank bridge, glancing at the minnows in the shallows and the airy blue dragonflies hovering above them, then strode across the bridge and on up into the neck. To my left lay several sliders, dry and matte black, on a pine fallen into the canal (the only such cut in the great woods, and well west of its bayshore) dredged to make the neck's causeway road.

Or roadbed. There ahead of me were the splintered crossties of an old logging railway, and what caught my eye was a round and rusted metal spike top, obtruding from the wood buried in the sand road and shining in the September sun like a gigantic copper penny. The wet woods to either side grew sweet gum and maple, and lavender flowers put spots of color against all this green. Now and again a frog jumped, landing heavily in the water of the canal, and that was noise enough for this pilgrim.

Only a half mile in, a canebrake began in earnest, filling the road shoulders and narrowing my field of vision. In a light southerly breeze the cane—some of it eight feet tall—heeled over easily and whispered *shush* with the wind like Capote's grass harp. And this song brought forth my snake. He, or she, sat right in the middle of the road and never made a move as I walked up to it, kneeled and held it, let it run through my fingers and fall from my hand as a child would let go of jacks. It was a viper *relicta*, for bleached bones in a little white pile were all the swamp had left of it.

I moved on out of the canebrake, staring up at gum tree mistletoe, at a pair of big navy choppers that rattled the air and shook Bull Neck, staring too at the hypnotic vanishing point that drew me forward as so many others like it had before—wet woods at Big Flatty Creek, at Cedar Island, in the Great Dismal Swamp. Something was there, just a few feet ahead, a quarter mile, mile at the most, yet it would reveal itself only if one kept walking, watching, waiting. The

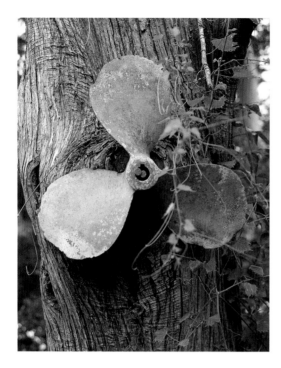

Prop on tree

skeleton of a snake, the skeleton of a railroad, the neck of a bull, and whose bull was it got loose and wandered these wild-woods and for how long, bellowing long and loud enough for someone named Spruill (or someone known to or kin to a people of that name) so to christen the big swamp and the bay beside it?

A pair of unseen wood ducks flushed, and wings booming in flight up a canal in such a forest will wake a body from such a dream. I was now more than a mile from Deep Creek Landing, alone in bear country, never mind bulls, and I recalled the tale of my cousin Thomas Yerby, who two generations ago was sheriff of Tyrrell County and who once, returning from a deer hunt hereabouts, found the swamp lane back to his vehicle blocked by a large black bear that, upon seeing Thomas, lumbered purposefully toward him. Thomas came out all right, though—he had a shotgun and buckshot, and he was loaded, as it turned out that day, for bear.

Back down at the landing I stopped on the rude bridge and regarded a twenty-odd-foot derelict on the creek's south side, a cabined craft lying where it had been retired and left to go to pieces. The brush and vines were too thick for me to get right up to the boat without a blade, but something else was shunted up in there too, and had been for far longer than any humans of any name were ever even in this realm fishing, hunting, fashioning boat hulls, or knocking big trees down.

A vine of muscadine, the deep purple grape of which the hearty scuppernong is a sport, was heavy laden with ripe fruit. So on my way out of Bull Neck Swamp, to the Old Country I tipped my hat, and then filled it.

The Huck Finn Trip, 1999

After nearly two years of planning and talking it up and pulling together our Huck Finn trip, then-fourteen-year-old Hunter and I finally made a summer run in our seventeen-foot Boston Whaler from little Washington, North Carolina, down to Beaufort, but first we took a turn up on the Alligator River, eighty miles northeast of the big outing.

With Jake Mills along, we three first headed for Spruill country, eastern Tyrrell County, for a short two-day outlier trip, putting in early afternoon at Old Cove Landing on the Little Alligator, site of the old timber village where my great-grandmother's family, the Moores, appeared in the 1870s from Maryland in a schooner and she soon met my great-grandfather Joseph Spruill of the big farm Free and Easy. We cranked the 90-horse Johnson and cruised down Little Alligator to Big Alligator and then across the three-mile-wide river to try to find the entrance to Mill Tail Creek, crawling along the eastern shore and finally seeing the opening, guarded well by shallows and a few cypress and logs and grass, and going in and up Mill Tail five miles to the lake. Years later after many outings there I would see, only once when a wind tide had blown the water out to the west, the pilings of the old railroad wharf where ninety years ago the logs of Buffalo City got rafted for tow across the Albemarle to the Dare Lumber mills in Elizabeth City. Fighter jets flew over us as the hard-to-start engine revived at last and we made it back over the river to the cove where Willy and Feather Phillips lived with their son Jake. Then we went to fishing in the dusk, on till dark, with Willy and Jake Mills and me having a drink and talking about Willy's peelers, his soft-shell crab shedder trays, and how the market for soft-shells worked, while Hunter was just a-yanking them in from the waters Willy had been chumming with crab parts from the shedder trays. This drew more than just fish, for two huge snapping turtles, cooters with heads like Rottweilers, came forth for the chum feast.

We ate dinner outdoors by candle and lantern light, and Feather fried so many soft-shells we couldn't eat them all. The talk piled on thick, tales of the bear lady, the onetime chorine who lived in the swamp just south and fed a tribe of bears on dog food she acquired in Manteo thirty-odd miles over two big waters to the east, and of the wreck of the *Sun Treader*, an ungainly cruiser with a Jacuzzi up top whose owners sailed her straight into an Albemarle blow and sank her scarcely out of the mouth of the Alligator, and of Durant Island over that way. Next day Hunter and Jake and I circumnavigated Durant's marshes and high live-oak-and-pine dunes and skirted curtains of rain in East Lake and then made our way back up the Little Alligator to the takeout and thence to little Washington. The shakedown cruise was done.

Next morning Jake saw us off at the creek at Washington Park. Hunter and I set out onto the Pamlico River in a mist, then quickly a driving rain, so we rigged a tarp up over the bimini. Then it was slow going against a wind, and we made more leeway than headway, blown and

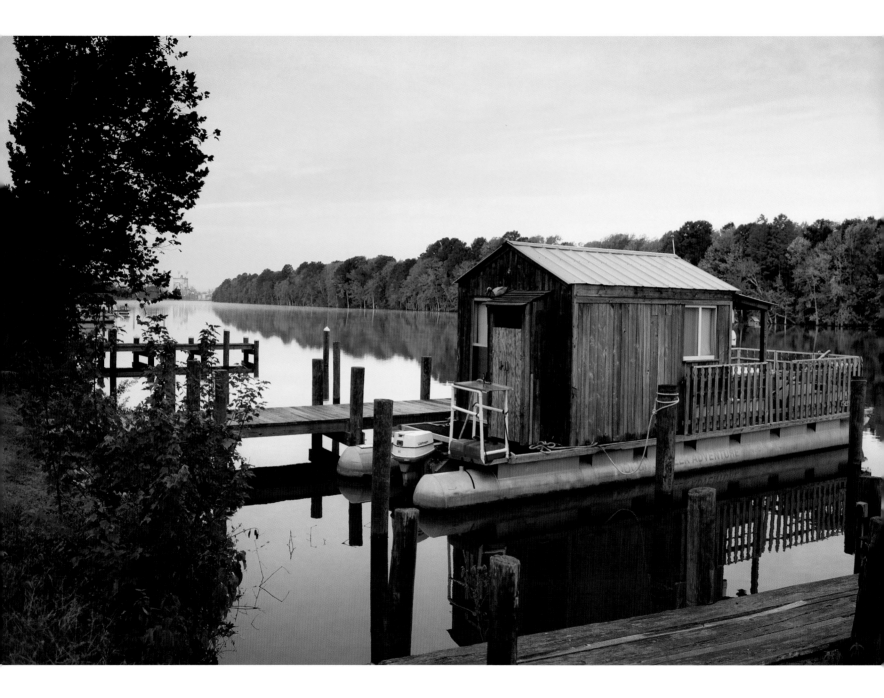

drifting to the far side of the river. As often happens in coastal storms, the wind and rain quickly passed and we ran on downriver to Bath, North Carolina's oldest town, laid out by the young English explorer John Lawson in 1705. We slowly moved up Bath Creek, even as the pirate Blackbeard must've back in 1718 when he more or less took control of the fledgling colony that was then run out of this place, and tied up at Bath Marina hard by the little bridge, and I asked Hunter: "Would you like to stay here for the night, till the weather clears a bit?"

Hunter gave that notion a big yes, so I booked us a room. Turned out it had cable, and all of a sudden Hunter was watching world cup soccer and I was off to the supermarket in the marina loaner car to pick up some potatoes and steak for us. Roughing it, sure, if you count the part about our getting soaked to the skin all morning, though now it was late afternoon and we were dry and enjoying a very nice, if temporary, home on the river.

From Bath next day we ran on down the Pamlico to the Pungo, and up the Pungo to the amiable old pile, the River Forest Manor in Belhaven. In the midsummer heat we prowled around town, passing yard after yard full of small, baked American flags out in advance of the 4th of July. No one was abroad and we were quite alone, to the point that Hunter declared: "Dad, there's no one here, this place is creepy." We drifted on to Mrs. Way's marvelous museum, a shrine of indiscriminate collecting that includes the state of North Carolina done up in buttons, old currencies from the Confederacy and doubtless other defunct nations, pickled fetuses and tumors, a tattered suit that once belonged to the world's largest man, and, who could forget, the fleas' wedding. At breakfast we ran into near neighbors from Bingham Township upstate, Norman and Nancy Gustaveson, who were on their way to see the moving of Hatteras Light back away from the sea. Hospitable as the big old wedding cake of a house is, we were on our way too, southbound for Oriental most of fifty miles away.

Many rivers to cross, under a leaden July morning sky: down the Pungo, over the Pamlico, threading the big cut of the waterway past the small fishhouse wharf at Hobucken, over the mouth of the Bay River and around Maw Point, across the broad shoals and into the mouth of the enormous, baylike Neuse River as well as into the face of a ten to fifteen southwest wind, a steady chop to bang against the whole ten- or twelve-mile way to Smith Creek and the cut by Fulcher's fishhouse at Oriental, while Hunter lay up on the Whaler's bow, singing into the wind, a bright sunny day on the big water and all the glory of a boy's joyful noise.

In the Ol' Store run by Cap'n Billy Truitt and his wife Lucille, we studied their own phan-tasmagoria collage, less dusty and daunting than Mrs. Way's and with a heavy maritime theme: the couple had fished together on the Neuse for years, and Lucille had at least a couple dozen lovely, detailed model boats—fishing boats, working craft—on the higher shelves around the store, even a model of the ghost ship *Carroll A. Deering* carved on Hatteras out of a piece of that very ship's timber. When I asked Cap'n Billy how to find Clubfoot Creek on the other side of the four-mile Neuse the next day, he showed me Great Neck Point and the heading for it and asked me in return: "You came up the river yesterday against *all that wind*?"

"Yes, sir," I said. We were standing at the foot of the street, gazing off at Great Neck in the smoky distance.

"Well, you did that, you'll not have any trouble crossing over to Clubfoot Creek."

Back at the Oriental Motel & Marina, thinking about our long run down the inside coast the

previous day and that powerful blast we met and pounded against for nearly three hours, my holding the boat to quarter the foot-and-a-half to two-foot waves that came at us, or we at them, every five seconds, my legs as sore from this treatment after it was over as they ever have been, I made a prideful declaration to Hunter, as if we were true conquerors, saying: "What do you think? The Neuse River belongs to *us!*"

Hunter, wise beyond his years, gave me a paint-peeling look of incredulity and silenced that silliness in a heartbeat with his honest response: "No, Dad. The Neuse River belongs to the wind."

Tranters Creek, 1999

For most of a cool, sunny Wednesday in December 1999, we three *voyageurs* floated the upper swamp of Tranters Creek in eastern Carolina: historian David Cecelski in his light gray, toothpick-thin kayak, poet Michael McFee and I in my long white canoe.

Tranters is a major tributary of the Tar River between little Washington and Greenville, and early in the Civil War, on June 5, 1862, a water-powered sawmill and cotton gin on a bridge downstream of where we now paddled was the site of the Battle of Tranters Creek. By this time in the conflict, Union troops controlled all of eastern Carolina's river ports except one—Wilmington, protected along with the rest of the lower Cape Fear River by the two-mile pounders at oceanside Fort Fisher that kept the blockade at bay. Yet the Federal lines scarcely extended past the western edges of the little rivertowns, and Confederate troops using the Sound Country swamps as camps and cover routinely challenged the bluecoats. On this day in June, though, the Yankees with infantry, cavalry, artillery, and a gunboat fairly routed the Confederates, who were massed at Tranters Creek but not well dug in, some in the cotton gin on the bridge itself, others behind cotton bales, and still others in trees near the bridge. When they fled under heavy rifle and cannon fire, the Confederates left behind muskets, shotguns, sabres, three dead, and pools of blood in the dust of the road.

The most recent battle hereabouts, though, had been with the elements. Just over two months earlier, in September 1999, the heavy floodwaters of successive hurricanes Dennis and Floyd had backed up and flooded the Tar River from Tranters all the way to Greenville, a good fifteen miles. Here in the upper swamps, one could see in the short holly trees near the banks

and on the hummocks how high the floodtide had risen; eight- and ten-foot-tall trees beside the creekbanks had been totally underwater and were still frosted with mud. The Lord *was* willing, yet His creek *had* risen indeed, spreading from its normal width of twenty or twenty-five feet to a wet span of many miles.

McFee and I came around a bend and, to our surprise and hers too, here came a small doe swimming directly at us down the middle of the channel, only two or three canoe-lengths away. She stopped still for a couple of beats, made a ninety-degree right turn, and got out of the creek as quietly as you please. She walked warily behind the trees, and she moved almost like a child tiptoeing noiselessly through the swamp, halting and looking out at us from behind one cypress, then another, till she had at last disappeared. Moments later a huge barred owl took off from the treetops above us and flew away, showing his tail feathers and flapping loudly as he followed a branch of the creek up and out of the bottom and quickly vanished.

What was a flood, any flood, to these creatures but one more cause to move or die? They mourned nothing, and their progeny, unthought of and unborn, were even so already far more prepared than our kind to meet the rising waters in eastern Carolina's sea-level swamps, more of which would come with Hurricane Isabel in '03 and Nor'easter Ida in '09. The deer, the bear, the otters, and the owls would someday see—or sense—the ocean coming on before we ever did, and might suffer less from its arrival. The eighty-pound doe that December day feared two unarmed men in a canoe more than she feared the great sea itself, the very Atlantic whose breakers and boiling surf were really so much closer than any of us dared to admit to this gorgeous hidden blackwater called Tranters Creek.

In Wilmington, on Wrightsville

When Daniel and Sallie Page left their small tobacco farm in Tar Landing in 1900, they moved on down the coast just a little way, to Wilmington. Whether he knew it or not, their fourteen-year-old son Julius, who would become my grandfather, had had all the formal schooling he would get. He had finished eighth grade and that would be it.

In the old port town Granddaddy went straight to work as a carpenter's apprentice, and he loved everything about it. He would tell me sixty years later that he knew in an instant the first time he picked up the long tray of carpenter's tools with its dowel handle, as soon as he had it in

his hand, that he felt the trade in his soul, that what he wanted in life was to become a master builder. So over the next few years in Wilmington he learned the carpenter's trade, how to join, frame, trim. And he learned the mason's and the plumber's and the roofer's. He learned it all and he learned it extraordinarily well—in less than ten years he would be traveling the Coastal Plain of North Carolina, responsible for renovating and fireproofing public buildings, for building the new jail in Columbia in 1909 (whereat he met my grandmother) and the one modeled upon it over in Manteo shortly thereafter.

My grandparents kept returning to Wilmington whenever it was time for a child to come. My mother and her four siblings were all born there between 1911 and 1920, and my grandfather worked there and from there—he helped build the two concrete ships that came out of Wilmington's yards during World War I, and he worked down at Fort Caswell at the mouth of the Cape Fear River. My mother was born in a large house on South Sixth Street in the first block below Market, not far from the fountain, a house with a pair of two-story bay windows.

On my mother's eighty-fifth birthday, my sister Sherri and I prevailed upon her to ride down from the red-clay country and go by and see her birthplace, which we did, even stopping and speaking to the current owner of the home, and to visit her older first cousin Gene Edwards, a retired businessman—he had owned a florist's shop, traded in real estate. In his younger years (according to my aunt) he had been quite the terpsichorean across the sound out at Wrightsville Beach, on the dance floor of the big beautiful seaside pavilion named the Lumina.

In that subtropical spot where the live oaks wind and grow everywhere and the palmetto is hardly uncommon, this mid-March day had an almost balmy aspect to it, and when we went to lunch with Gene and his family at the country club, it felt quite grand to stand outdoors in the New Hanover noonday sun and for a few moments bask. Inside at table we spoke, naturally, of family and old times.

"What'd my great-grandfather do once they moved to Wilmington?" I asked Gene, his name the first syllable in "genial," of which he was the tops.

"Daniel Page—I don't know as he ever did much of anything," he said, laughing.

"Now, Gene," my mother said. "He had a sign hung out at the house that said he sharpened saws."

"Yes, I remember seeing that *sign*. I just don't remember ever seeing him doing any *sharp-*

ening or anything else." Gene leaned back in his country-club chair, smiling and perusing his memory, and after a few moments he allowed: "Well, now, he *did* preach."

"I never heard this," I said.

"Didn't have a church or anything, but sometimes he'd get an invitation to do a guest sermon."

"What was his message?" I asked. "Generally."

"Oh, hellfire and brimstone is what he was known for. A bunch of us boys, you know, when we were in our teens, we used to get sent around on Sunday afternoons to see Uncle Daniel— he'd sit out on his porch, us in the yard, and he'd talk to us, preach at us."

"Saying what?"

"How awful bad we were, all the terrible things we were up to, or wanted to be up to, every- thing was downhill for us, he said. Said we were all going straight to hell. Stuff like that."

After lunch we went out to Oakwood Cemetery, where the unranked live oaks twine wildly above the venerated dead, to see where the long-gone kin were in the family plot, including Daniel Page and his wife Sallie, as well as Gene's brother F. D., the antique collector, and his other brother Graham, killed in a plane crash in World War II. Then Gene with a wry laugh pointed out where he would be, where he is now. We did not linger there but did shake hands a little extra long, knowing that this was likely farewell.

And then we were off to Wrightsville Beach to spend just a few minutes before heading back up into the red-clay country. I drove slowly south down the soundside, the late afternoon sun- light slanting over and goldening the wide marsh. When I came back up the island, parking in the middle, my sister and mother and I strolled out on the sand, down to the surf, picking up a few clamshells and bracing ourselves for just a bit against the late-afternoon Ides of March chill. As we walked, with side-to-side staggers the way one does in deep sand, I could feel the grains sifting in over the top edges of my deckshoes and gathering under my arches, and I left it there and felt the sand in my shoes all the way home.

Currituck, Fall 2004

In late September, the fall of 2004, Ann, young daughter Cary, and I were once again eastbound for the weekend, this time to stay at the Snowdens' place in Currituck, just down the Curri-

Sunset over wetlands

tuck Sound shore a bit from the old courthouse where my father often searched titles back in the 1950s and '60s and within easy view of the comings and goings of the Currituck–Knotts Island ferry. We found the turnoff, drove through the beanfield (where the soybeans were still green and a good three-and-a-half-feet tall), pulled up by the soundside cottage, parked, and unpacked.

When I got to the top of the stairs and opened the door, I gasped.

The Snowdens' place was nearly identical to my family's Kitty Hawk cottage from days gone by, so close in size, shape, and layout (a large open front room with windows around the sides and the soundview front, an uncovered deck overlooking the water, same distance from the sound that ours had been from the ocean) that inside of five seconds I was feeling the strongest sensations of déjà vu I have ever had, and they were very good indeed. When the grand

honeysuckle-white full Harvest Moon rose over Currituck Sound that evening, Ann and I, looking out eastward from the livingroom, knew that we had stridden into one of those moments most all of us mortals dream of: in love with each other and at peace with the world, our twins now grown up and in school, our younger daughter healthy and asleep in the other room, and the goddess Diana pouring a gorgeous silver light in upon us from across Currituck, the Indians' Coratank, "where the wild geese fly."

The next day we rode the ferry on over the sound, past Live Oak Point on Mackay Island where wealthy duck hunters once roistered at the invitation of publishing magnate and waterfowler Joseph Palmer Knapp, who kept a place (it looked for all the world like Mount Vernon) and many a duck-blind in the vast marshes there, and on to Knotts Island, where we drifted up Knotts' east side and picked apples and scuppernongs and bought muscadine wine made right on that old spot by the vintners of Martin Vineyards. Enjoying our pickings and sitting out on the Snowdens' deck once back on the mainland, Ann and I watched the Harvest Moon rise again way off yonder over the Currituck Banks, while just below us, down by the water, another magic circle was closing.

Cary had tired of fishing on the little dock, put down her pole, and started to ramble along the sound shore, its only inhabitant, picking up and earnestly studying the small flotsam she came across in the shallows. Then she encountered a floating log, six feet long perhaps, a little way down the shore, tied to it a short length of algae-green rope she had also found, and began tugging it along in the shallows, which she had since early childhood always called "the short water." Perhaps the log was tugging her—either way, it took a good while for her to muscle it along and pull it back to the dock, for, though afloat, it was waterlogged, heavy, and she worked it alone.

Or so it may have seemed to her.

Stomping in the soundwaters, tugging on that log, perhaps Cary could not see or sense just then all those who have roamed by here in the old days and the ancient age and the times that antedate antiquity itself: all the land-bridge pilgrims, all the Algonquians, all the lost colonists, the early Currituckians and Albemarlians and the later ones, those after timber and those after fish, clammers and oystercatchers, captains and crews, the lifesavers and the shipwrecked, all the spirits already starting to come forth in the gloaming as the moon rose that evening, all the

Sand prints

ghosts that haunt the great estuaries and varied coasts of Carolina. Yet she would come to see and sense them, the very best of them, we would hope; and we would hope for her too the full measure of this pantheist's prayer, this jazz-song plea, this lover's entreaty, four words we speak often as so many before us have spoken, or whisper, or even just imagine and therefore set them afloat toward the spirits, toward the abiding and embracing spirits of the Sound Country, this wet and water-loving land, to the creeks and swamps, to the marshes and rivers, to the narrow sounds and the broad sounds so wide they seem like seas unto themselves, and, always and forever, to our mother the sea:

Never let me go.

Girl and dogs on the Banks

During that golden hour in the shallows I kept thinking: What I would give to fix, capture,
encapsulate this little moment and offer it back to these noisy innocents when they are fifteen,
or fifty. It was as sublime as the Sound Country gods can make it, which is substantial.

Old Pea Island Coast Guard
Station and Herbert Bonner
Bridge, Oregon Inlet

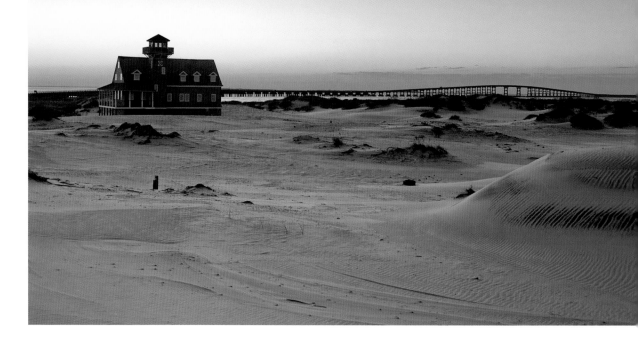

Sunrise on the Outer Banks

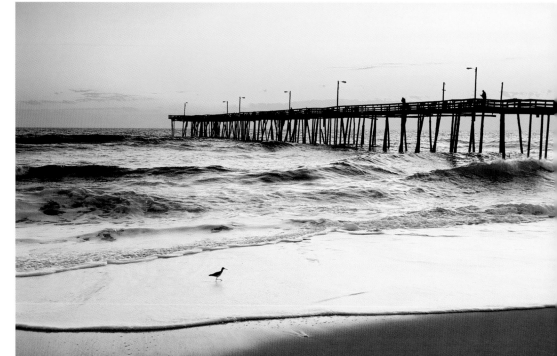

Pelicans at sunrise

Pelicans now go gliding low and slowly over the water, their long wet beaks glistening in the morning sun that plates the rolling ocean and makes its green waters go gold, and the grand brown birds fly like messengers to the nowadays from the back times before history, bearing memories of mariners so ancient that even the sea herself must work hard to recall them.

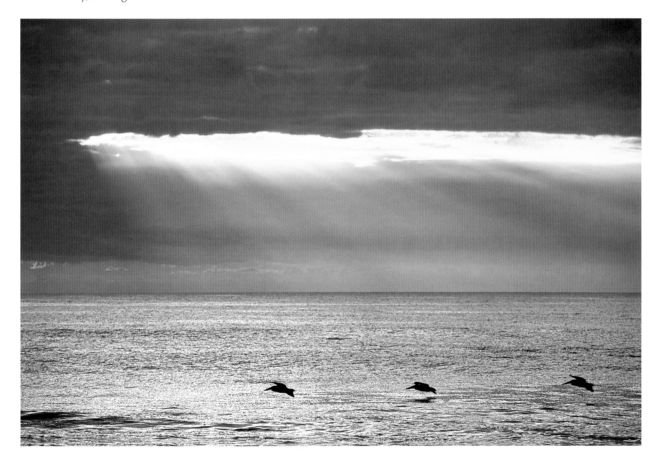

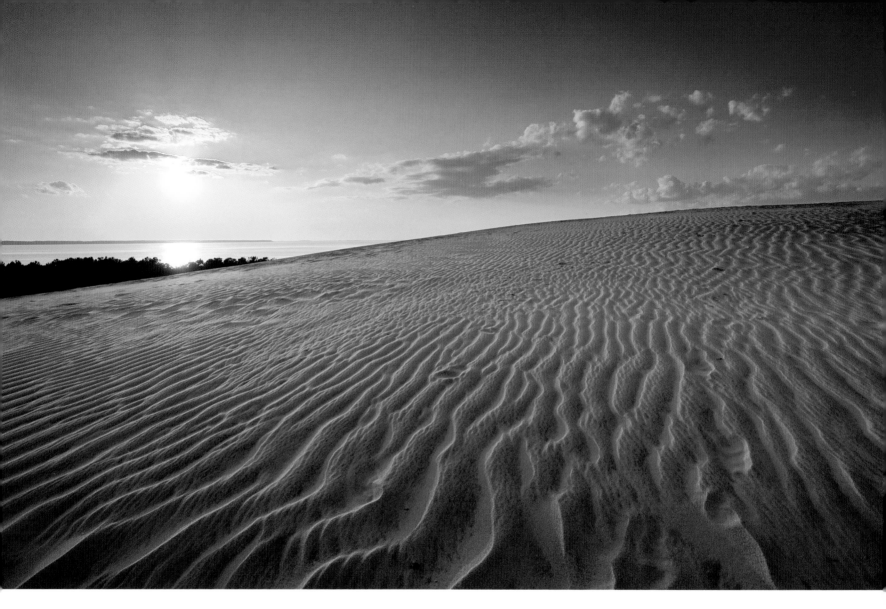

Jockey's Ridge, looking west over Roanoke Sound

We were climbing up that big tawny hill . . .
Looked like it was blowing away,
But it's forty-five years ago to the day,
And it's still right where we left it—right where it was . . .
So, Papa, here's your Sand Mountain Song.

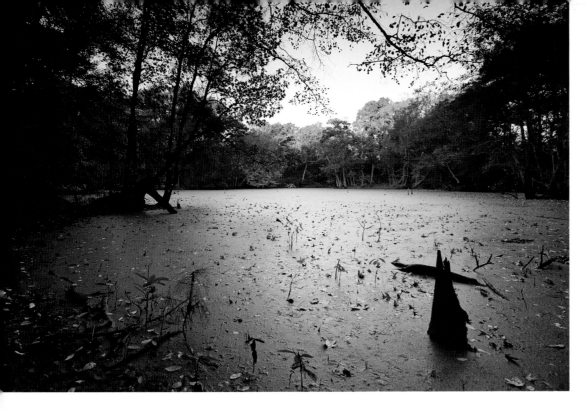

Nags Head Woods

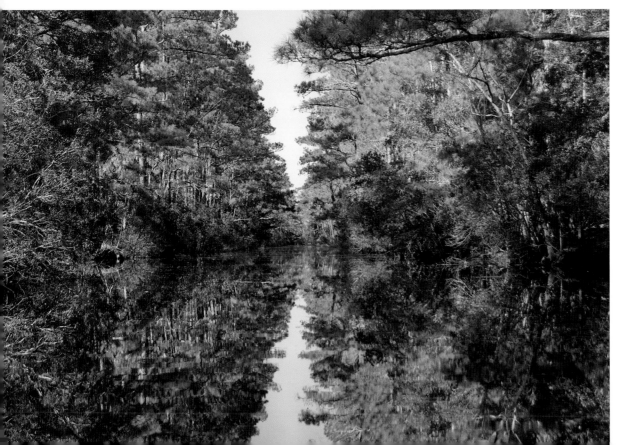

Kitty Hawk Woods

How I used to lie in my bunk bed on the western end of our small white cottage watching the grapevine hill back toward Kitty Hawk Woods show up in faraway silhouette as heat lightning lit the night sky, knowing somehow though never forming the thought that I was among Sir Walter Ralegh's latter-day colonists, and that the ruby and silver and gold he sought but never found had been here all along and were here yet, presenting themselves each fall in wild vineyards all across the realm and hanging from lianas that long ago tied me with a touch to the wild and wondrous Sound Country earth.

Cleaning fish on the Banks

Fishing at Cape Point, Hatteras

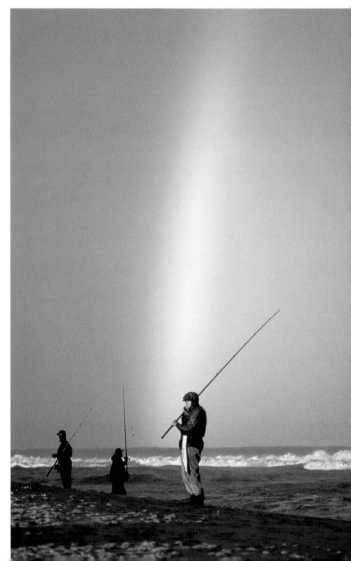

Muzel Belle Bryant at age 100,
Ocracoke Island's oldest resident

Howard Street, Ocracoke

Winter wheat, Currituck mainland near Poplar Branch

Pilothouse and signs,
Currituck County
near Powells Point

KITTY HAWK 70
ELIZ. CITY 35
NAGS HEAD 20
STATE LINE 35
MANTEO 30
EDENTON 70
HATTERAS 85
NORFOLK 55

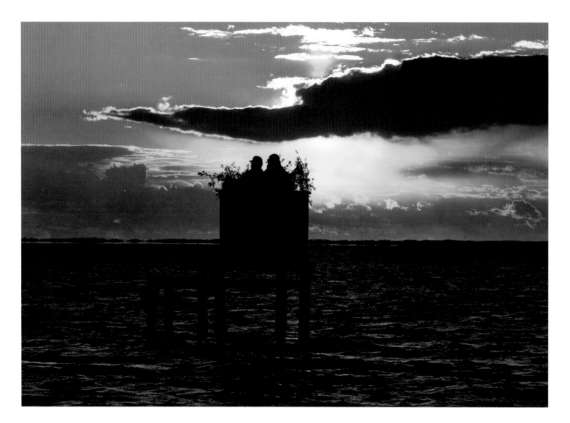

Duck hunting in Core Sound

I thought about the many old Currituck clubs there were, or had been—and about others at Mattamuskeet and Pamlico Sound, Core Sound too, and down on the New River in Onslow. Isolated places where hunters had gathered, hunkered down together, and then set forth in the damp and icy dark, paired in blinds about the sound awaiting the Vs of geese and the ducks at dawn.

Wilson Snowden and decoys, Currituck Sound

My father, coming home at breakfast time with a brace of ducks from his first-light Currituck hunts, had shot his limit, our evening meal, from a blind "out on the Sound."

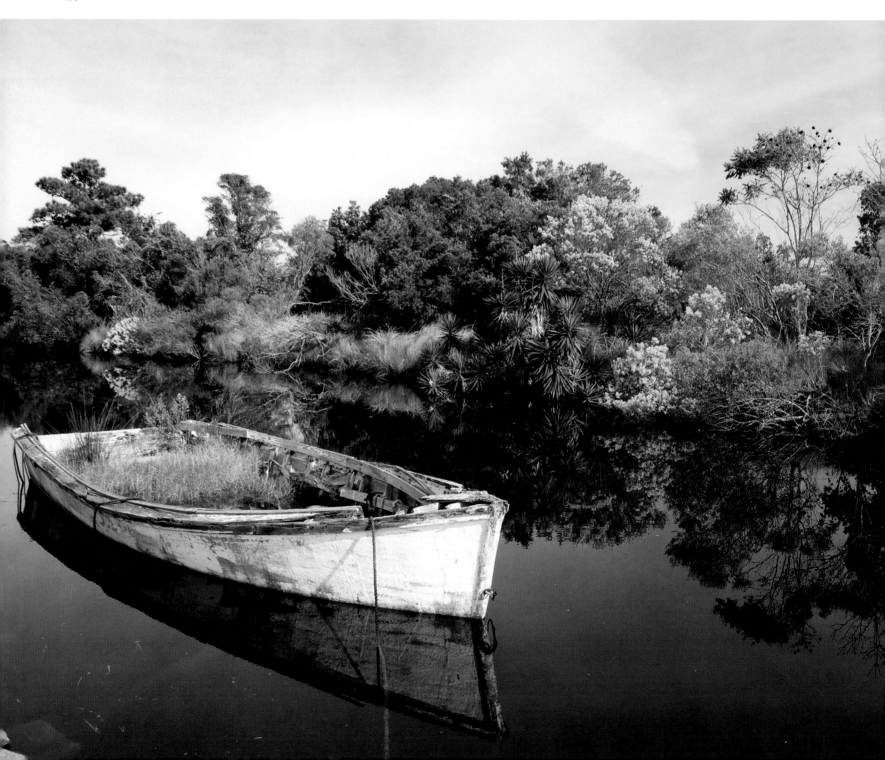

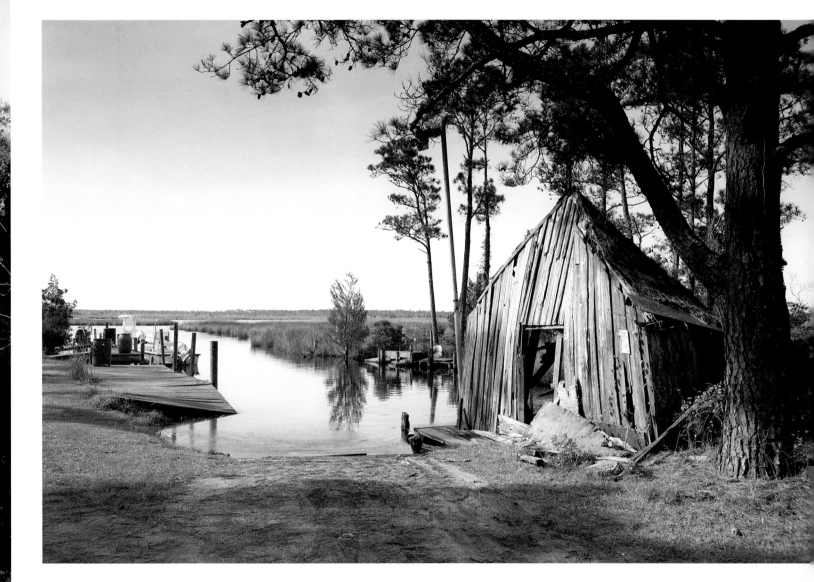

Mill Tail Creek, a tributary
of the Alligator River

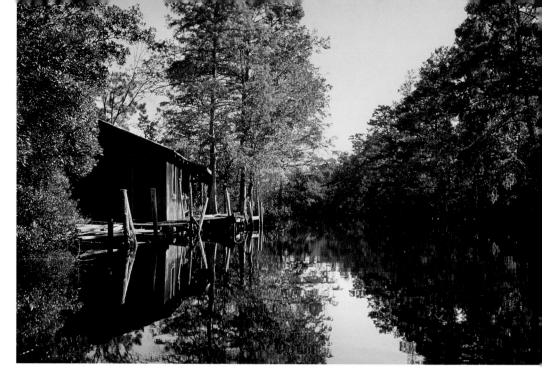

Wanchese,
Roanoke Island

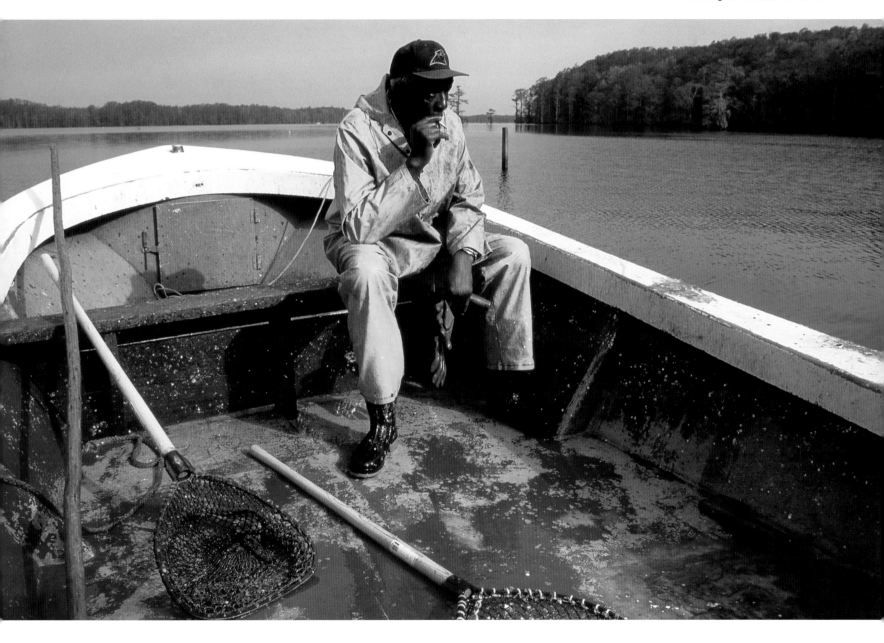

Trawler, Pamlico River

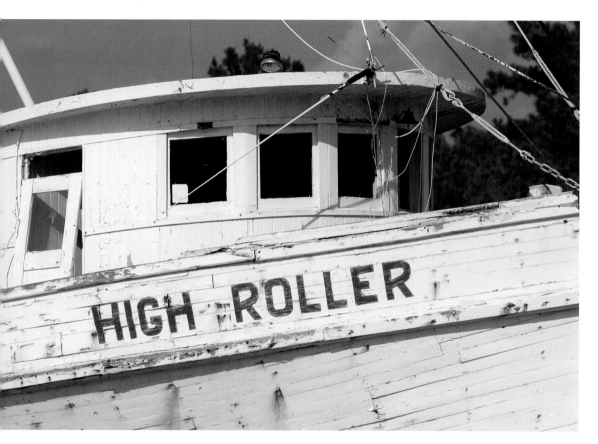

Grandfather, grandson, and blue crabs, Mackeys Creek

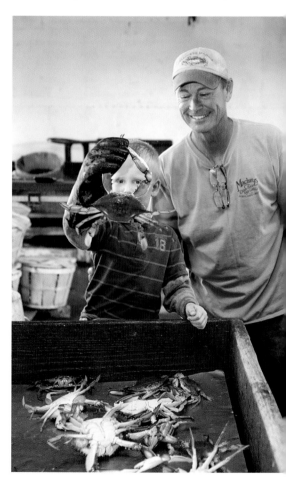

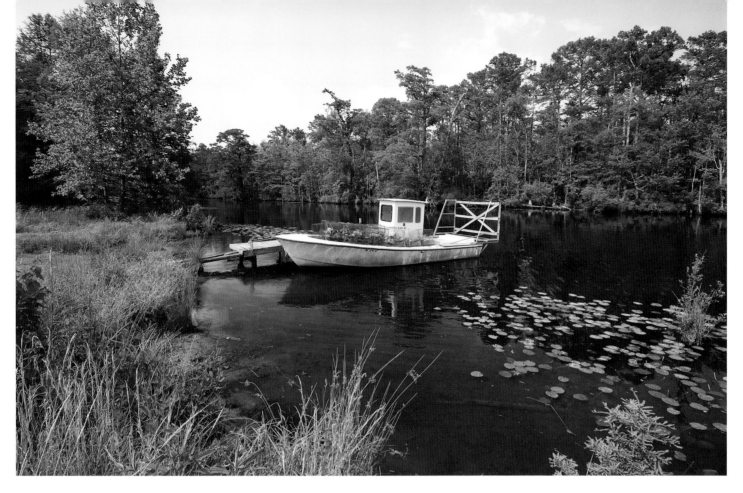

Boat with crab-pots,
Salmon Creek,
a tributary of the
Chowan River

Cow lily pads and fly line,
Salmon Creek

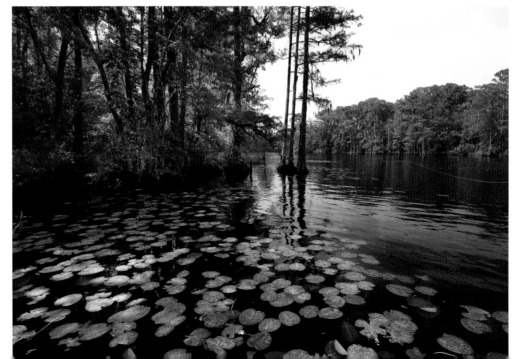

Waders, eastern North Carolina

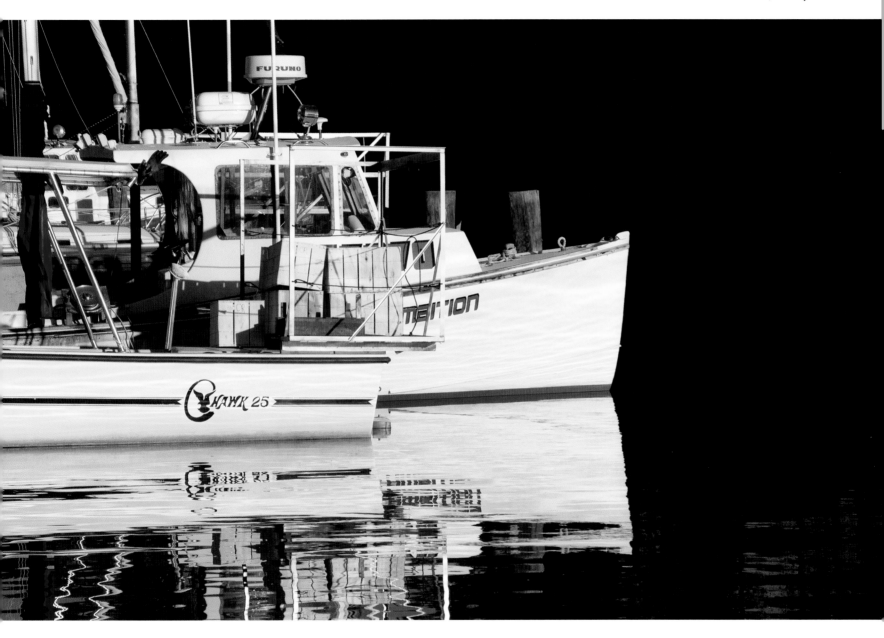

Cabin, North Core Banks

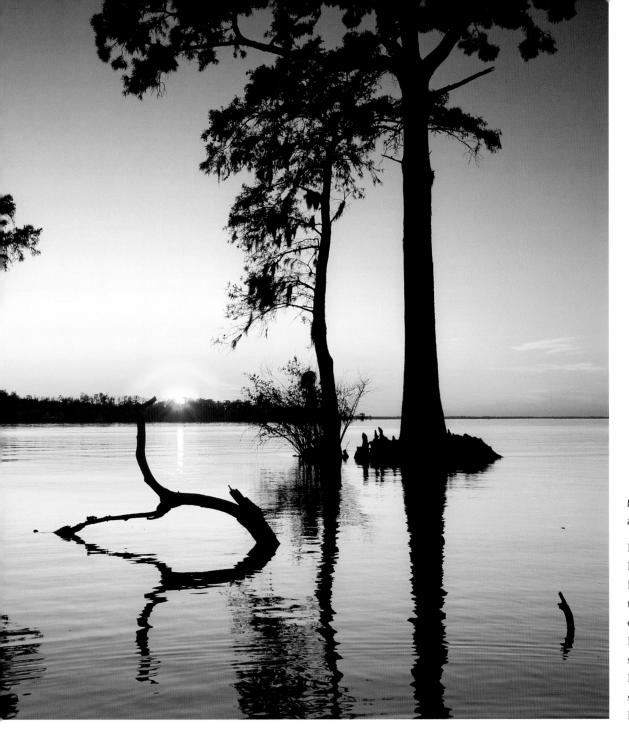

**Mouth of Mackeys Creek
at Albemarle Sound**

I wouldn't be at all surprised if Ralph
Lane and his tiny fleet looked in on
Flatty Creek when they were exploring
the Albemarle for Sir Walter Ralegh in
early 1586, sailing westerly and visiting
Indian villages along the sound's north
shore before turning up the Chowan
River, or at Mackeys Creek on the
south shore as they headed back to
Roanoke Island.

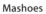
Mashoes

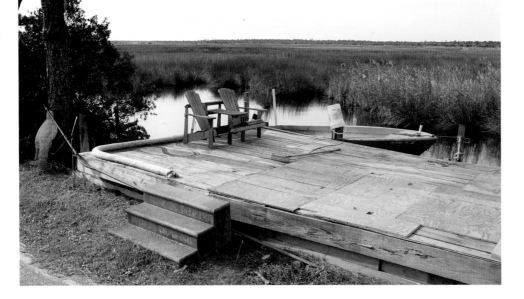

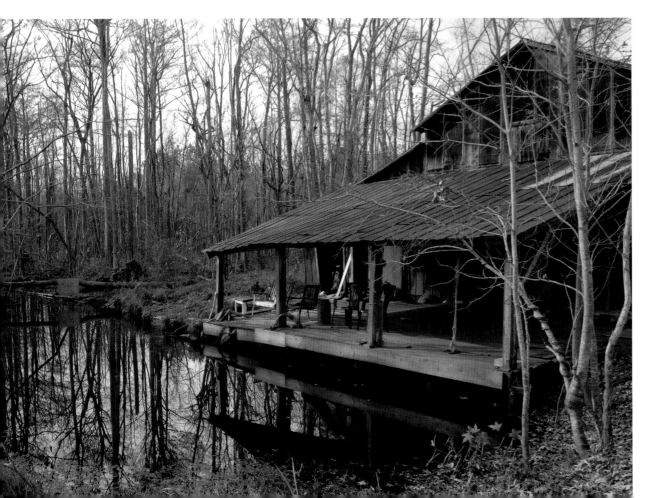

Creek off Beaver Dam Branch, near Mackeys

The small shed-roofed wharf was a place where fishing buddies sat after the boat was tied up and the gear was stowed, to watch dusk fall and to see the night come on and the gumwoods go black and the creek itself disappear.

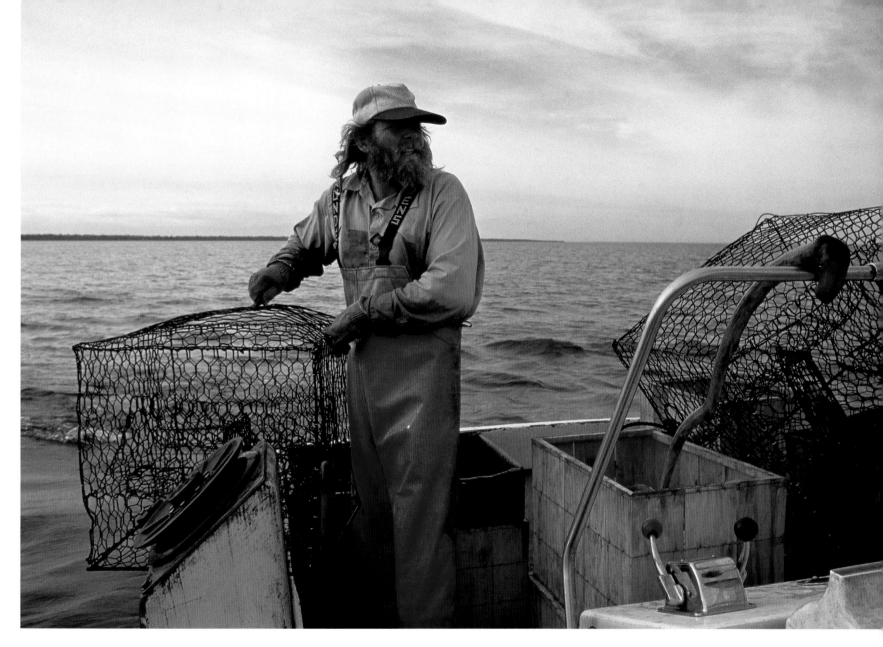

Willy Phillips, Alligator River

We made our way back across the Alligator River to the Little Alligator and our coveside camp at Willy and Feather Phillips's Fort Landing home. There Willy's soft-shell crab shedder trays out over the water and his wholesale operation, Full Circle Crab Company, were both in high gear and great form.

Old store, Fort Landing

Sitting by the river in the moon
light. sitting by the river with you
by my side. its wonderful with the
right one Sailing up the river
all a lone with you its so wonderful
sailing with the right one
singing songs to gather as we
sail a long. banjo strumming violin
playing. its wonderful what it
do to you.
—Old manuscript page found glued
to the wall of the Fort Landing Store
by Feather and Willy Phillips, Tyrrell
County, spring 1988

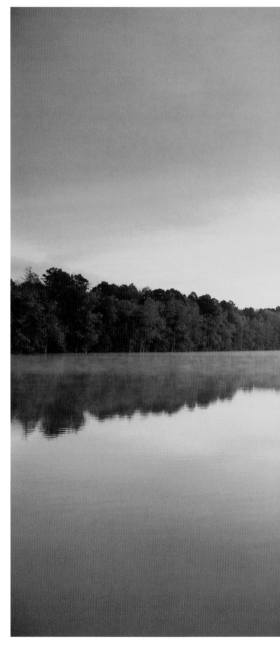

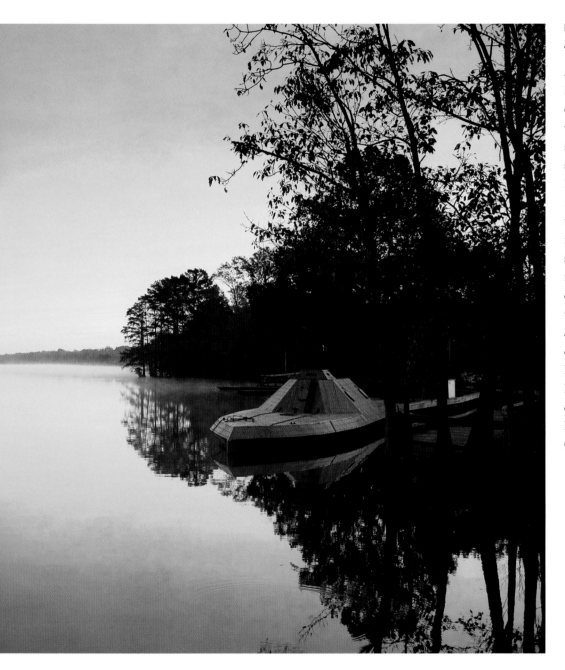

Replica of Confederate ram *Albemarle*
at sunrise on the Roanoke River, Plymouth

As we floated downriver past the historic little port,
I warranted that nothing about the riverine face
of the town and its extraordinarily quiet, relaxed
waterfront suggested that in this very place 20,000
soldiers and sailors once clashed in North Carolina's
second-largest Civil War engagement, the Battle of
Plymouth, a three-day brutality that ran from April
17 to 20, 1864. Hoke's Confederate forces, attacking
the occupying Federal garrison from south and east,
in league with the Confederate ram *Albemarle* that
sank one Union ship and ran off another, for a time
retook the port that had served the Union as military
chokepoint on the Roanoke River. Two weeks later,
the *Albemarle* would stand off seven Yankee gunboats
at the mouth of the Roanoke, but, before the year was
out, under cover of darkness on October 27, a Union
lieutenant named Cushing would boat up the river,
lay a torpedo up under the *Albemarle*'s metal decking,
explode it, sink her—losing his own craft and two of
his men in the bargain—and then swim safely away.
On Halloween 1864, Union forces retook Plymouth.

Sunset on Main Street, Columbia

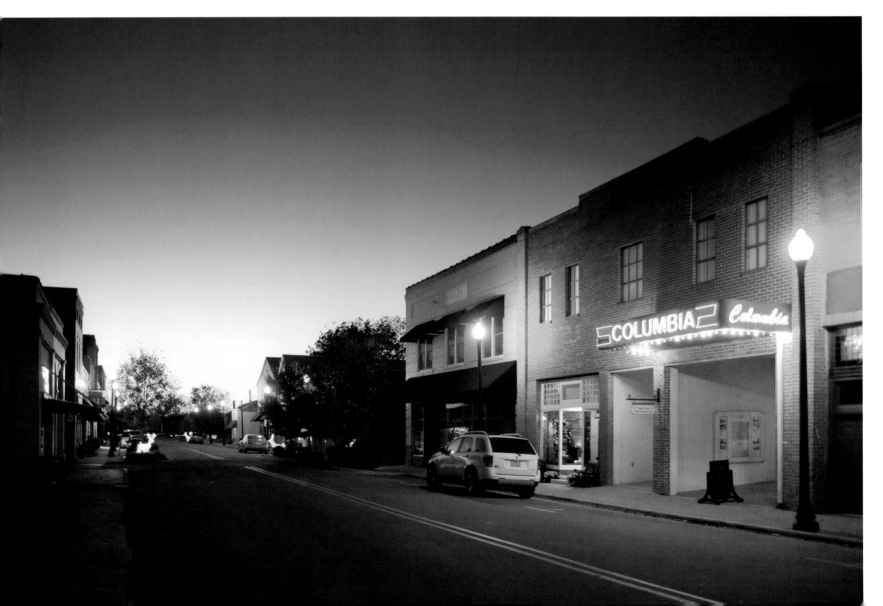

St. Thomas Episcopal Church, built 1734, Bath

Pamlico River, Washington

A wet and miserable wintry pall fell over little Washington during the night, and the morning was such a misty mess we thought more boating might be out of the question. Yet Sound Country weather is nothing if not changeable, and by noon the front had passed, and we had ourselves a brilliant blue-sky day.

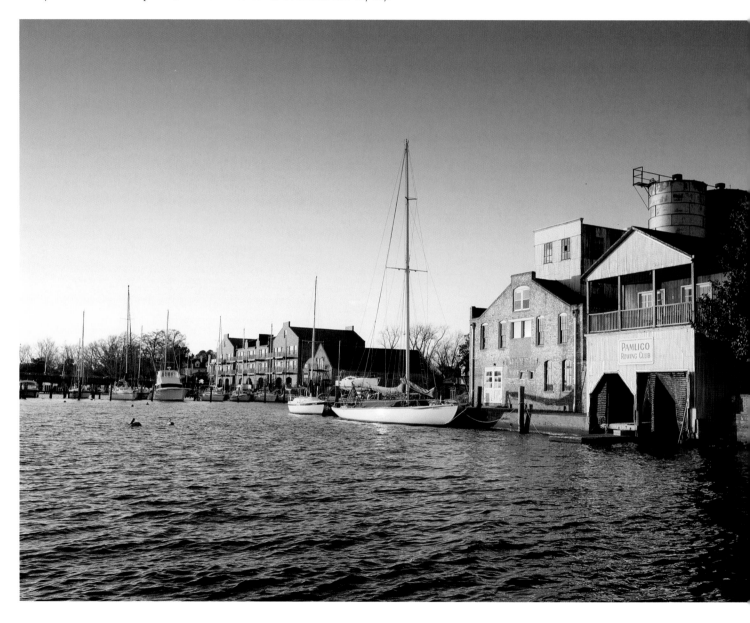

Rosenwald School,
built 1926, Alligator,
near Fort Landing

Belhaven Memorial Museum

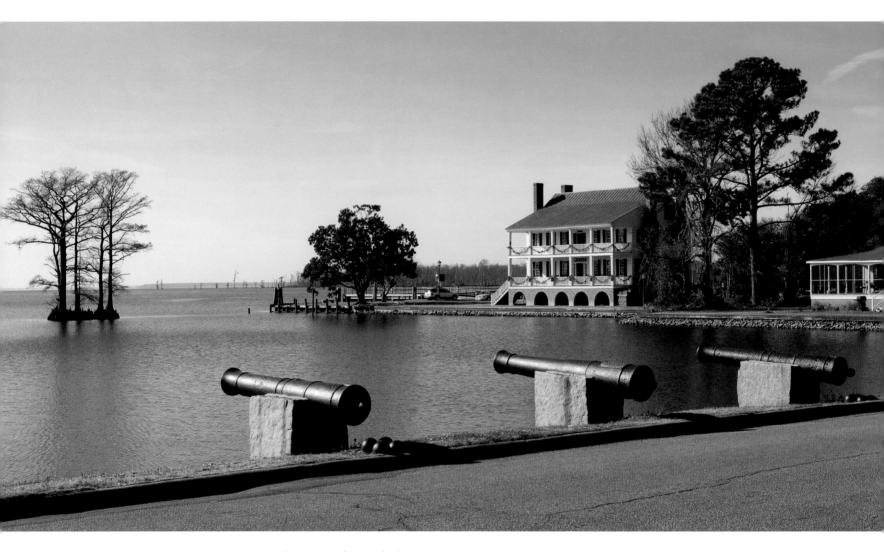

Edenton waterfront and Edenton Bay

The shining waters of Edenton Bay meet the Albemarle Sound just a mile or two east of the mouth of the Chowan River, and the town of Edenton itself is a colonial dream made manifest. Those old French cannon at the harborside might never fire again, but what a thunderclap over the cove they could make.

Tryon Palace on the Trent River, built 1767–70, New Bern

Down the Trent River I went, under the U.S. 70 bridges, through the old harbor of New Bern where bright blue canvas dressed up the white boats. Tryon Palace sat across the way, a monument to the last days of British colonial grandeur. "A very genteel house built, the only one of brick, on the banks of the Trent," the peripatetic German doctor Johann David Schoepf wrote when he saw it just after the Revolution, during the winter of 1783–84. "This palace, for it is honored with that much too splendid name, is at this time almost in ruins. . . . The state would be glad to sell it, but there is nobody who thinks himself rich enough to live in a brick house."

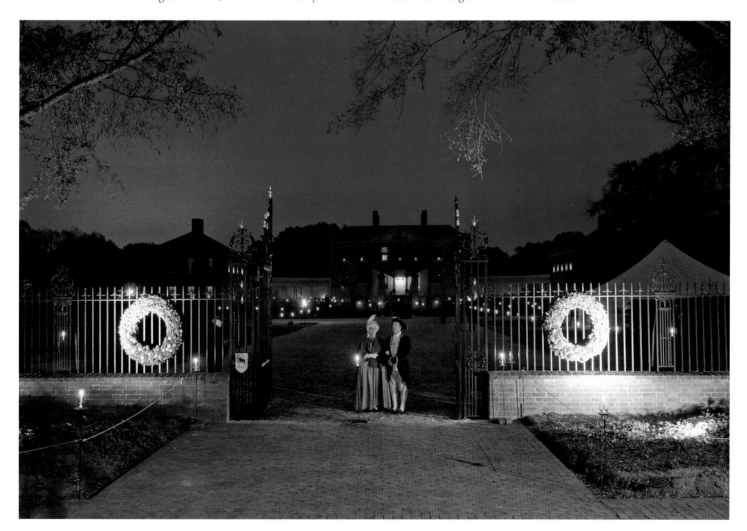

Ferry dock at Don and Katie Morris's Kabin Kamps, North Core Banks

At Don and Katie Morris's Kabin Kamps on North Core Banks, in tarpaper and tin and crusty-screened fish-shack #13, our daughter Cary took her first steps. This was where Ann had grown up, learning to drive an old stick-shift Peugeot in the sand, casting a line out in the surf, drift-fishing Drum Inlet, and pulling in two flounder at a time on a high-low rig.

Moonrise, North Core Banks

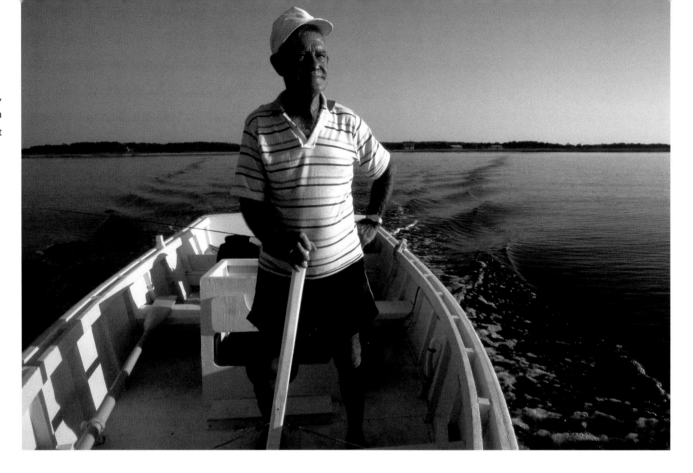

David Yeomans,
heading out from
Lookout Bight

**David Yeomans at
home, Cape Lookout**

David Yeomans—storyteller,
singer, fisherman and fishhouse
operator, civic and church leader
("I held every office except presi-
dent of the Methodist Women")—
was a man who moved back and
forth between his Harkers Island
home and his camp in the old
Cape Lookout Village on the
Banks and who for many was
the embodiment of both places.

Casa Blanca House, Cape Lookout National Seashore

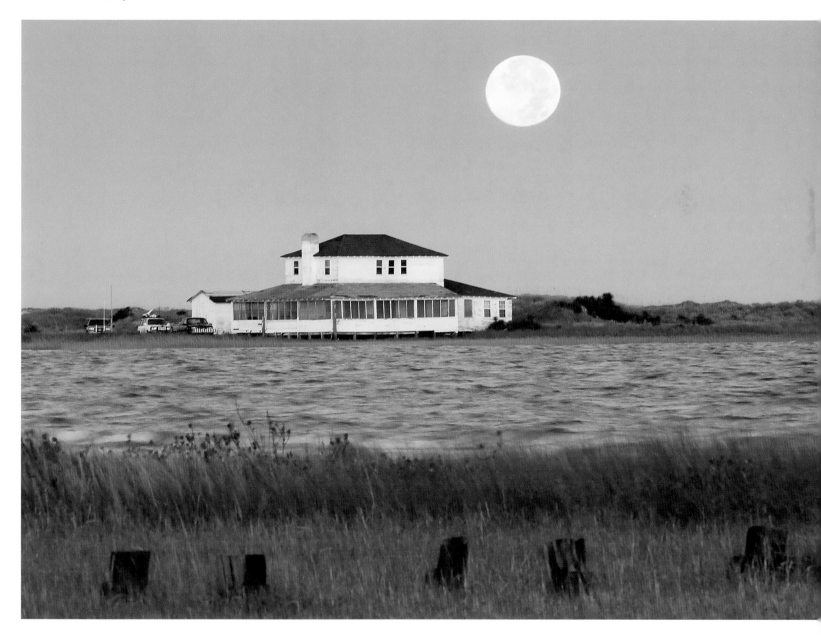

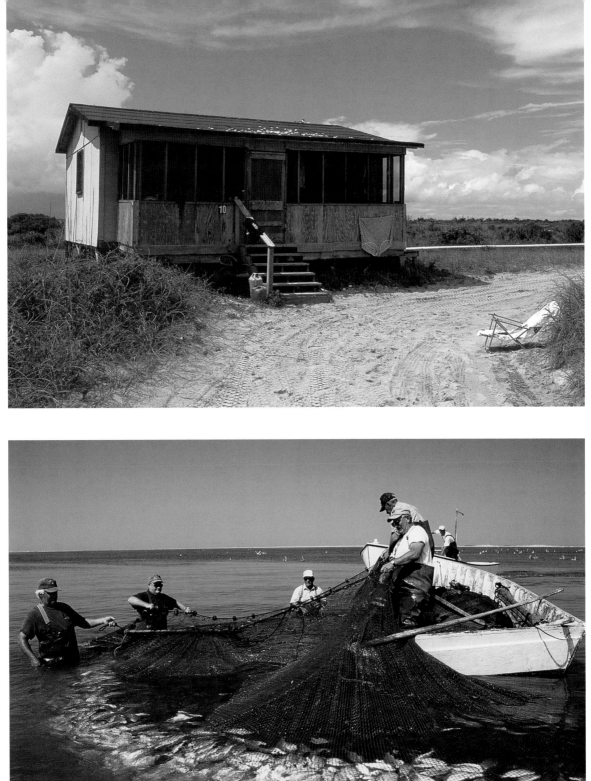

Cabin, South
Core Banks

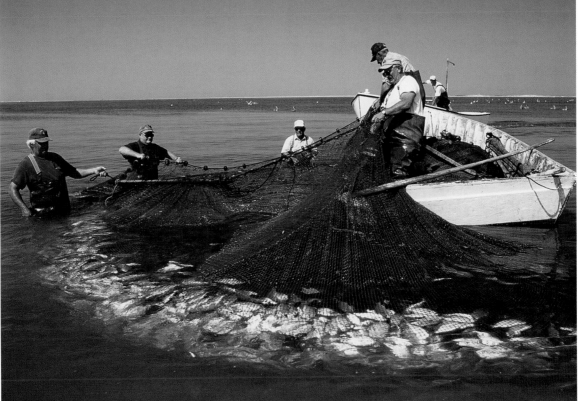

Spot fishing,
Lookout Bight

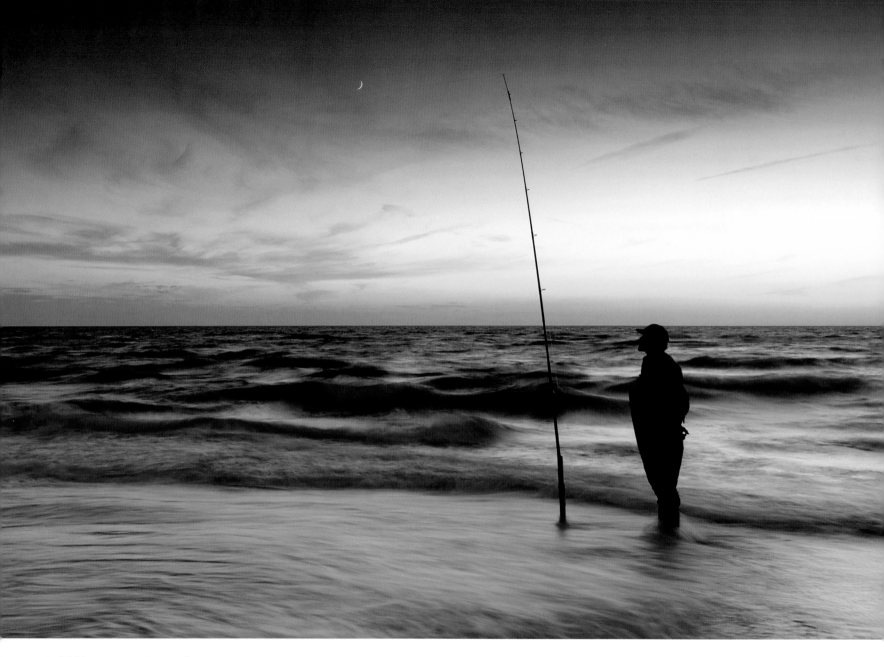

Surf fishing at sunset, Core Banks

Cape Lookout Lighthouse, built 1859, Core Banks

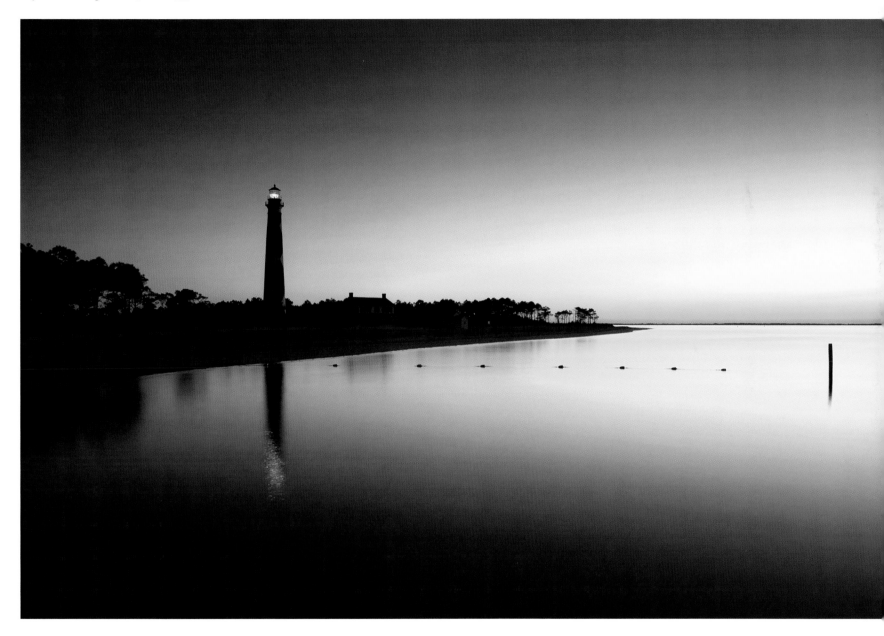

View from Barden House front yard after sunset, Core Banks

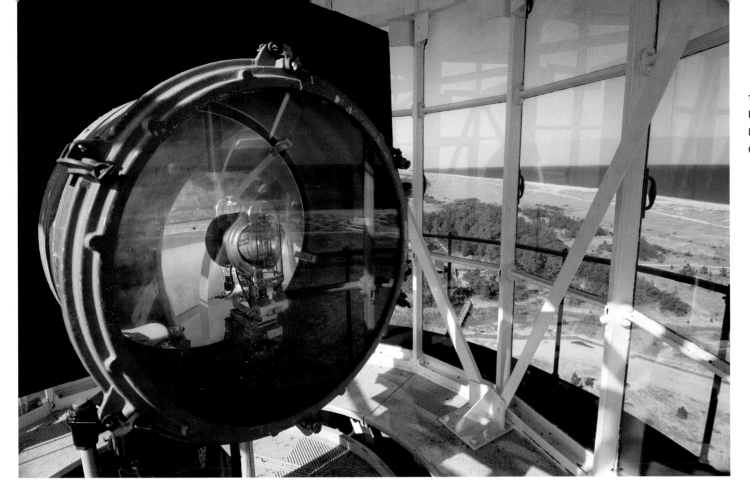

1,000-watt beacon,
Lantern Room, Cape
Lookout Lighthouse,
Core Banks

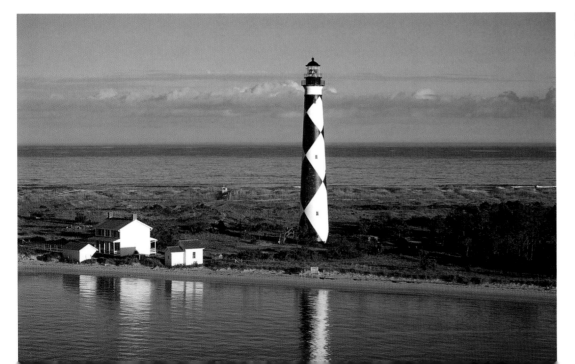

Cape Lookout Lighthouse, waters
of Barden Inlet in foreground,
Atlantic Ocean beyond

83

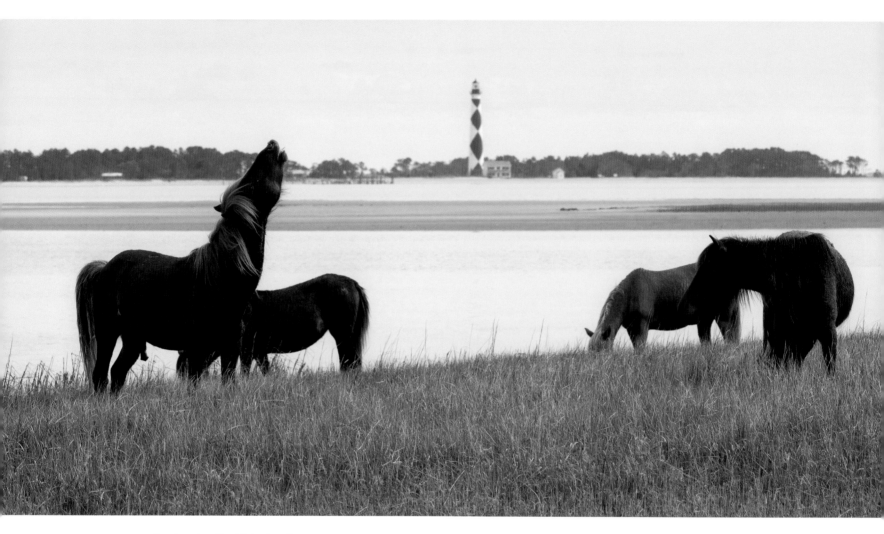

Sand ponies, Shackleford Banks

These ferals have been padding and prowling the Carrot Island chain and other islands thereabouts since someone no longer remembered put a small clutch of their forebears out there to graze free. This was an antique and much-honored practice, for both Outer Banks and inner islands were long considered and used as open range for all sorts and grades of stock, till a third of the way into the twentieth century. The ponies must literally fend for themselves, as the estuarine reserve brings them neither food nor freshwater. If they find no freshwater pooled anywhere on the islands, they must paw and dig down with their hooves till they come upon it as groundwater.

Male tern tries his best line to no avail

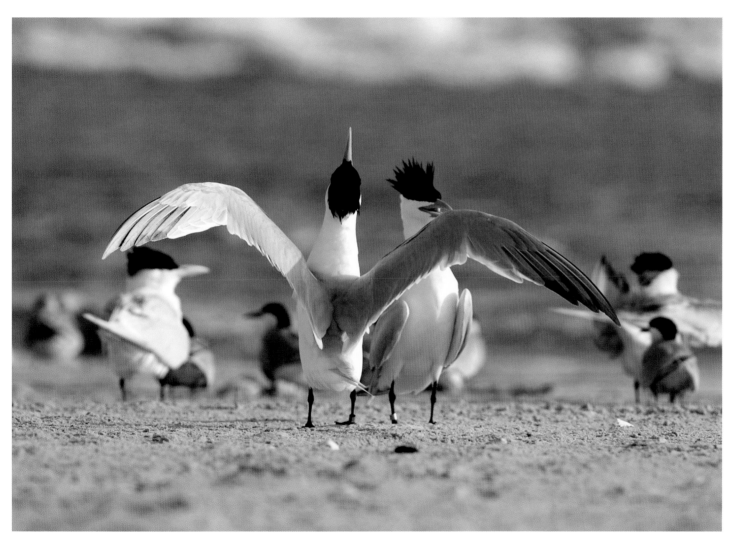

Sunrise on Core Banks

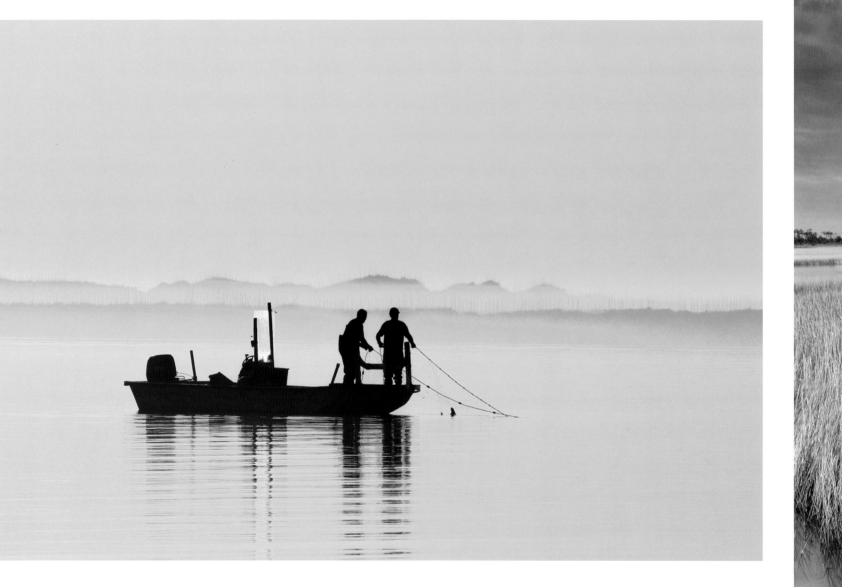

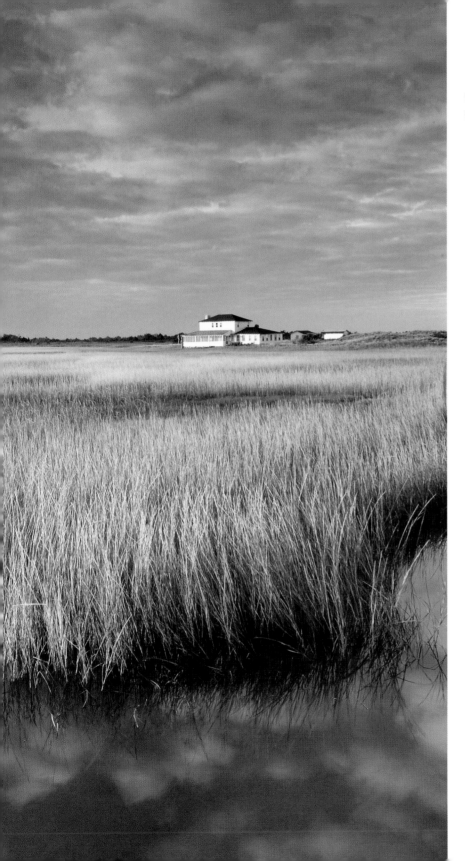

November sunrise on marshes and Casa Blanca
House, Cape Lookout National Seashore

Sunset illuminating window on Core Banks

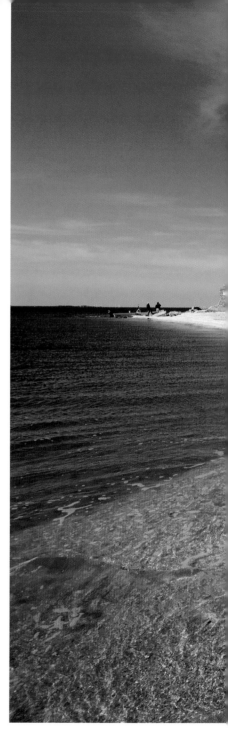

Prospect of Core Sound from Atlantic

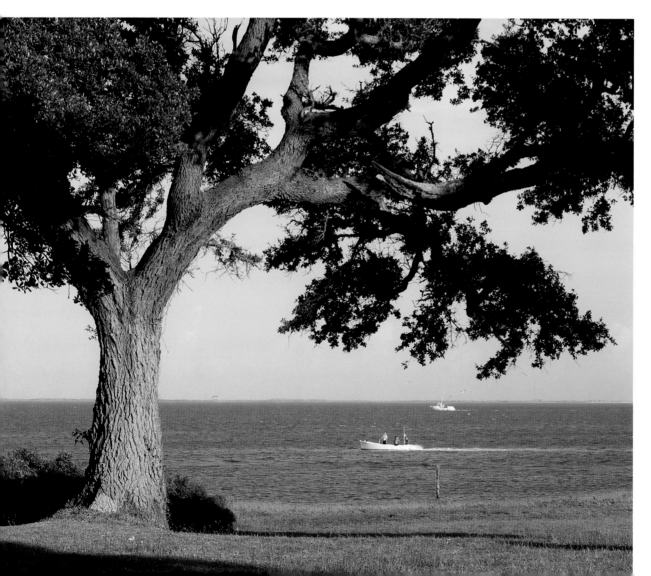

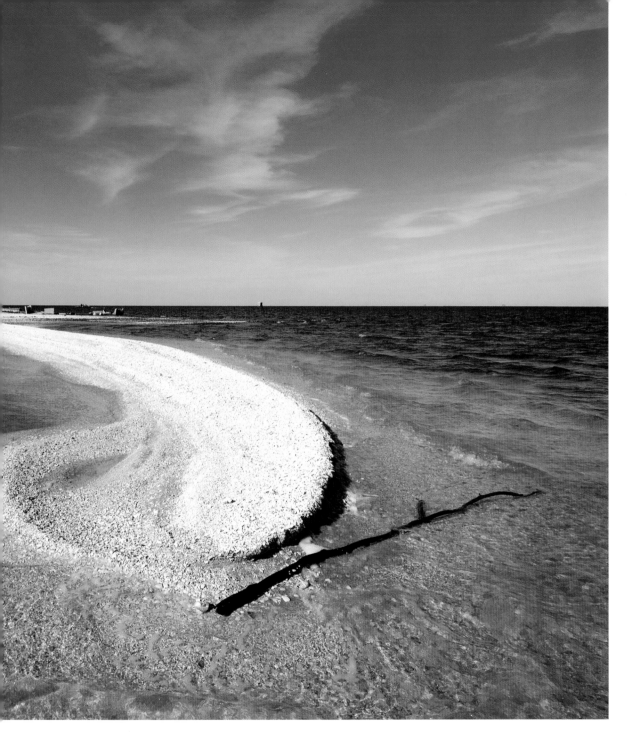

Harbor Island, Core Sound

Harbor Island is a scant half acre of bone-white shellbank curving away to east and west, with a tabby-walled hunt-club ruin at the western side of what little land mass it has. Unroofed and with vacant, eyelike windows, the stranded ruin stands guard over the two sounds' boundary, staring at but passing no judgment upon all comers, human and avian, fishermen and crabbers, plovers and pelicans, upon the long broad waters of Core Sound below it and the vast inland sea of Pamlico Sound above.

Fishing boat in wisteria, Sea Level

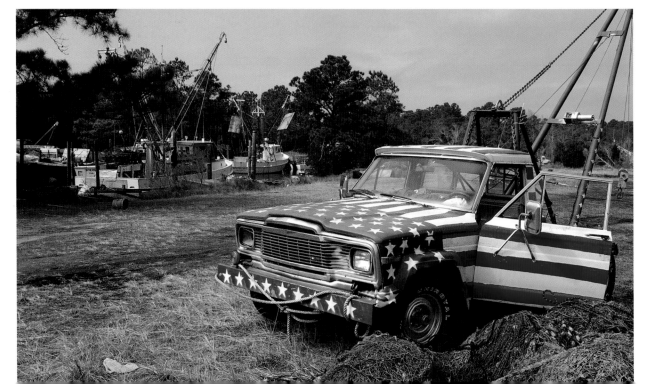

Boom truck, Cedar Island

Goats on skiff, Atlantic

Harbor, Cedar Island

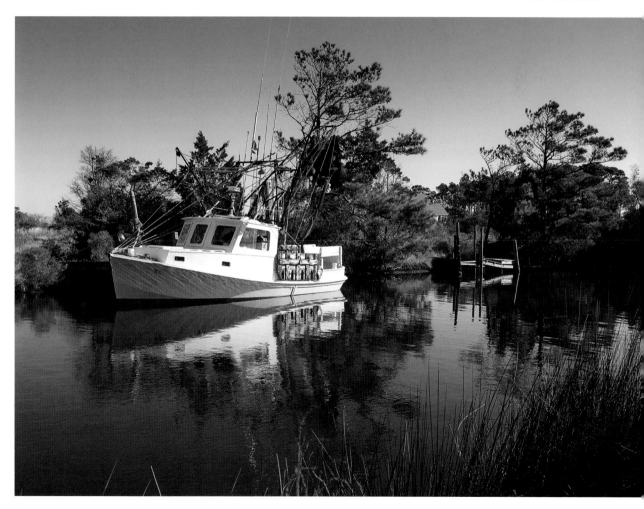

Farmer Styron and
Marshall Daniels,
Cedar Island

Still life, table with
good stuff on it

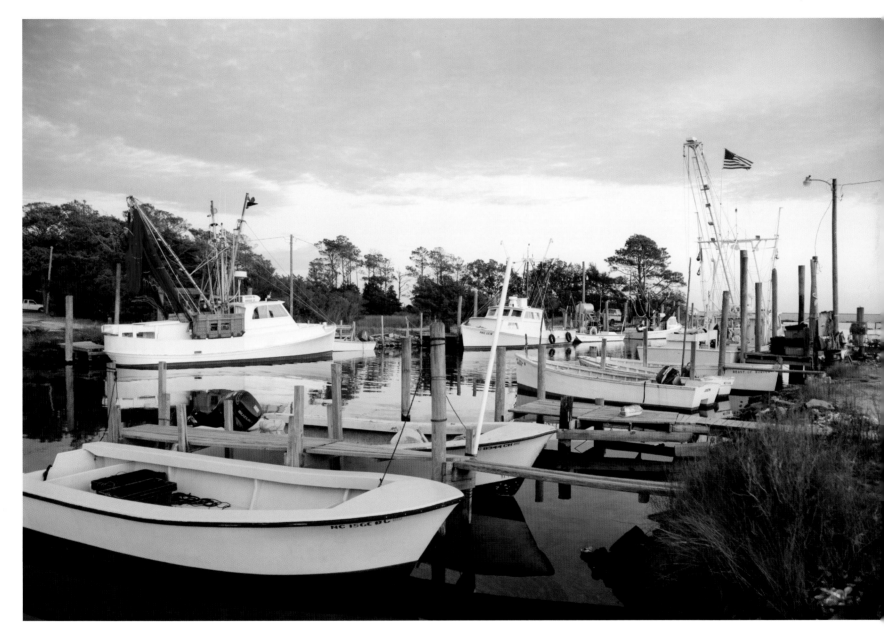

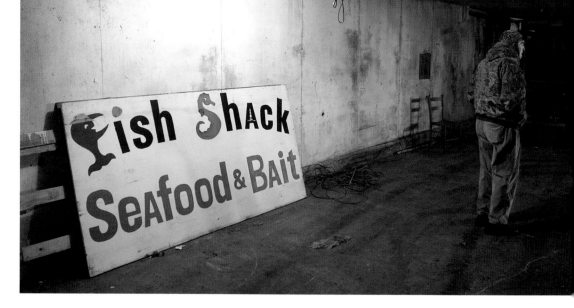

Fulcher's Seafood (closed), Atlantic

Marshall Daniels
tonging oysters,
Cedar Island

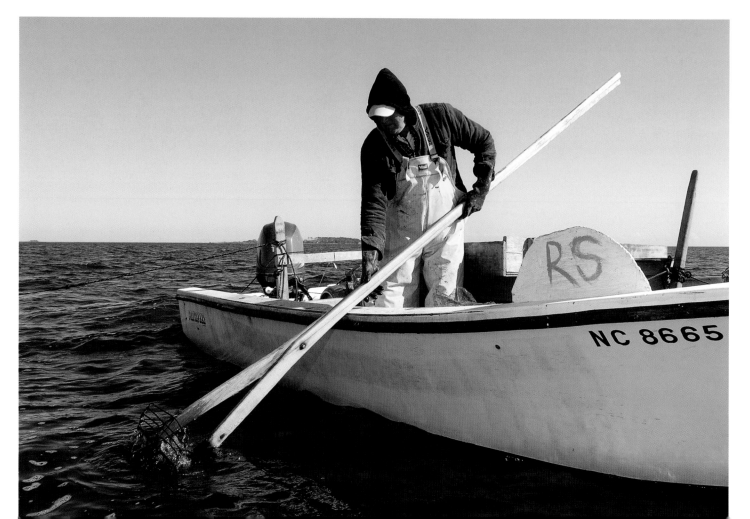

Boatbuilder and musician Bryan Blake with signs, Gloucester

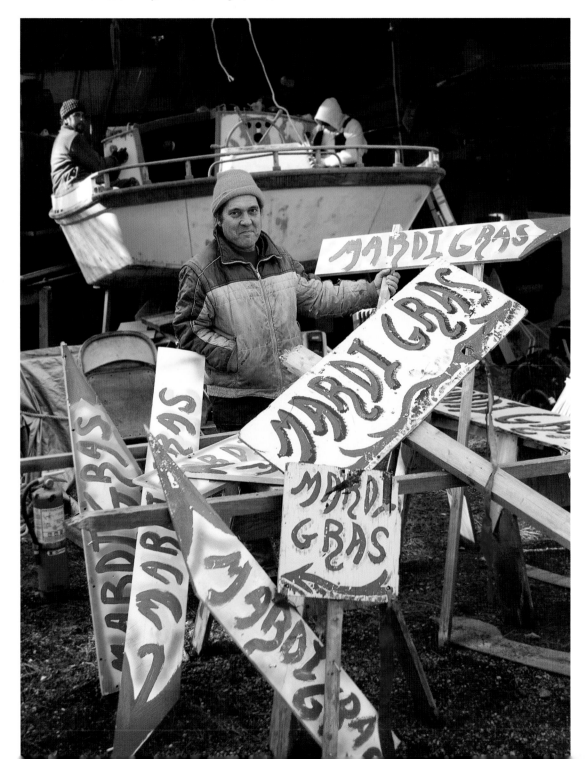

Native oyster on the half shell

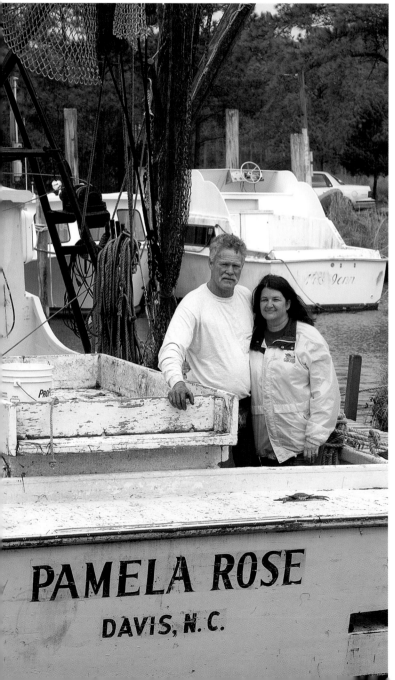

Herbert Morris and Pam Morris aboard *Pamela Rose*, Davis

PAMELA ROSE

DAVIS, N.C.

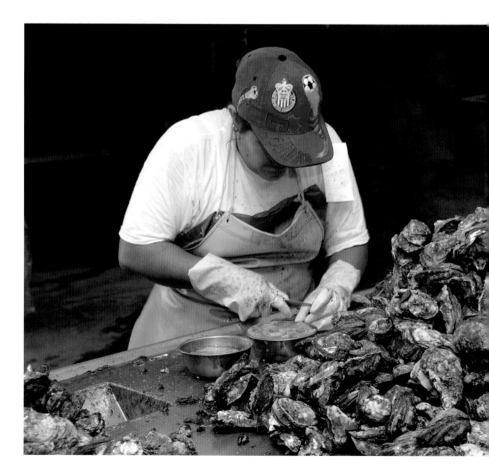

Shucking oysters

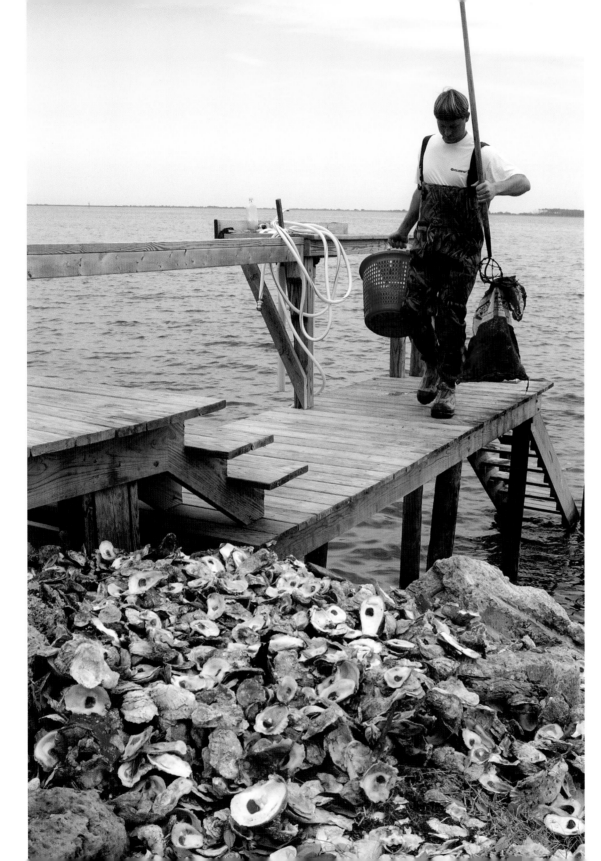

In from oystering, Cedar Island

How often I have stopped somewhere on the coast and picked up a bushel of salty oysters tonged that morning or maybe the day before and mud still on them, now all in a white-tagged sack, and headed west with the sights and the aromatic salt-marsh smell of the Sound Country filling my head.

97

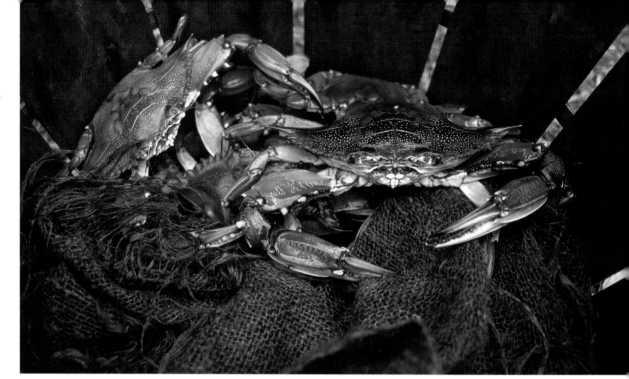

Blue crabs

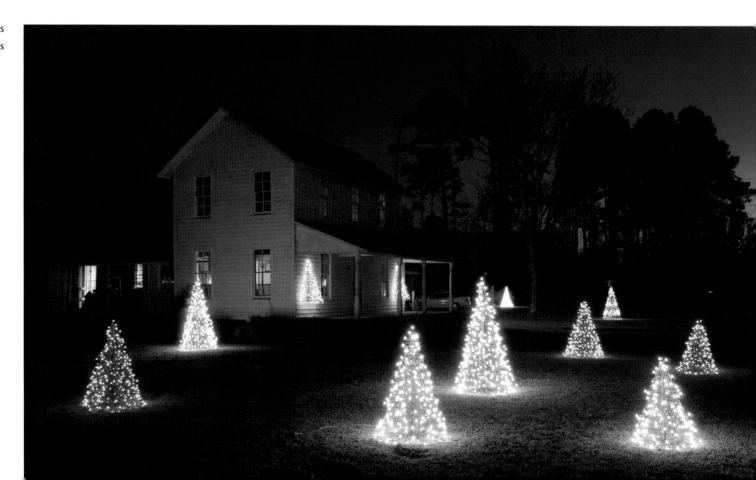

Crab-pot Christmas trees, Davis

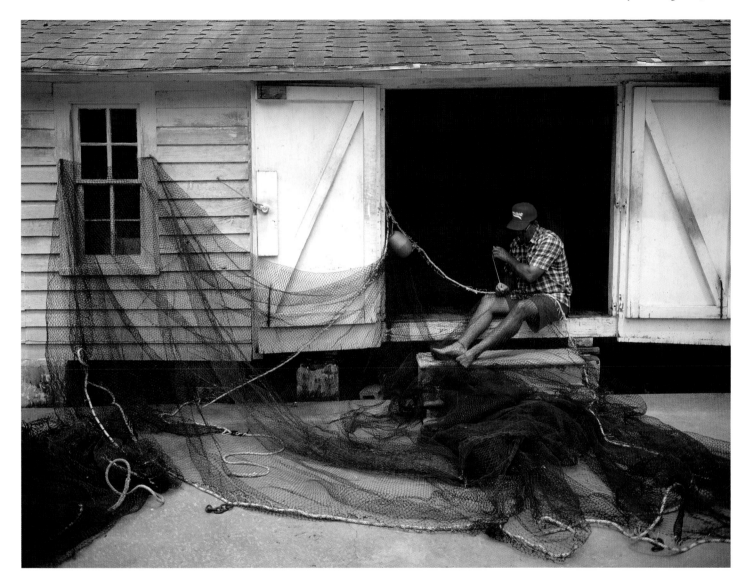

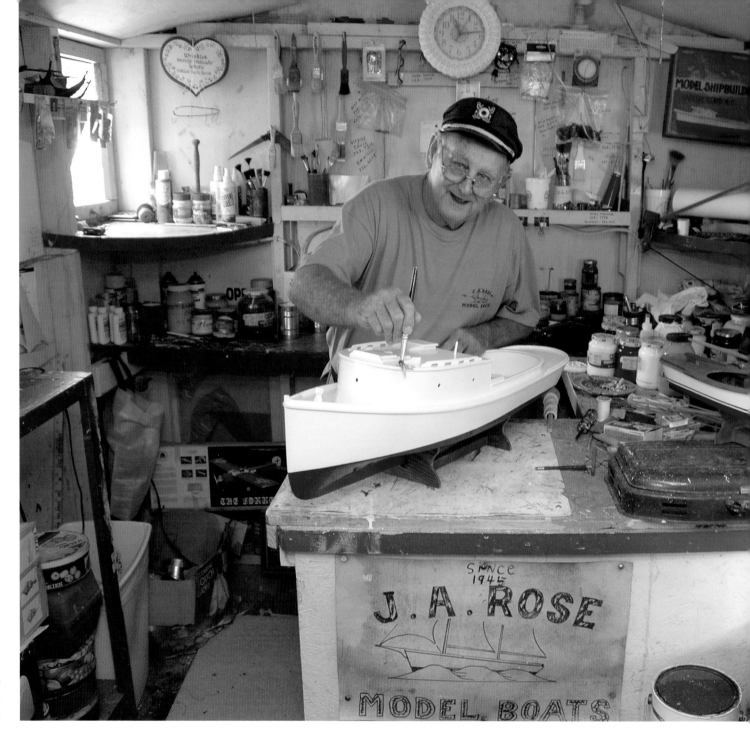

James Allen Rose,
boatbuilder and
N.C. Folk Heritage
Award–winner,
Harkers Island

James Allen Rose carving a propeller

Boatbuilding, Harkers Island

On Harkers Island, in backyards and garages and fair-sized hangars, by rack of eye they lay out and cobble and craft and fit out the flarebow boats that kick back the surf and spray of the bow-wave and that are first among equals in the boatyards of the world, small craft and large.

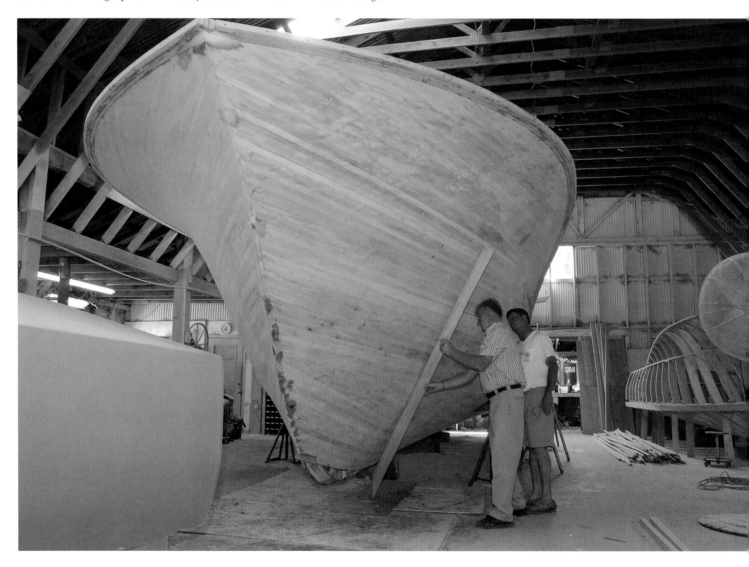

Mitchell Lewis
sighting a line,
Harkers Island

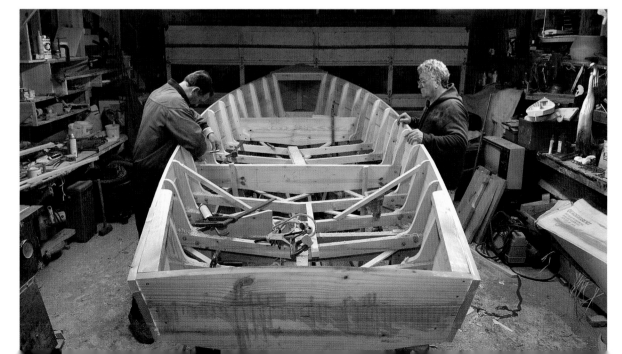

Heber Guthrie and Jimmy Amspacher
building a skiff in the garage,
Gloucester

It has been both a privilege and a
pleasure for me to have watched the
keel for a sixteen-footer being laid
in a small shop on Harkers Island, to
have seen a skiff awaiting its finishing
coat at mossy Gause Landing in
coastal Brunswick County between
Ocean Isle and Sunset Beach.

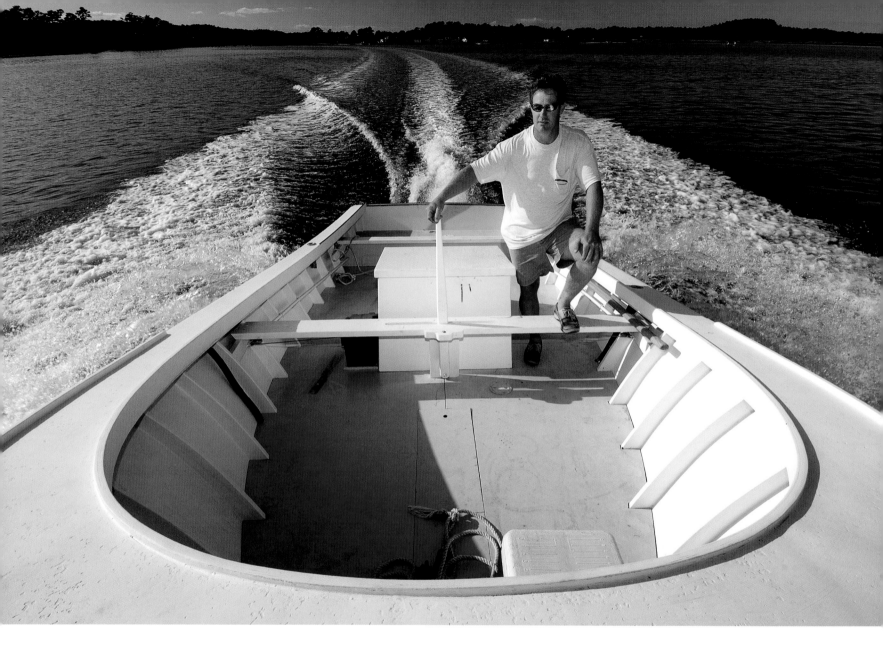

Taking her for a cruise, Jarrett Bay

In waters like these, you want a boat that really *will* just about ride the dew. The plain old skiff—sharp prow or snub nose, flat bottom or dead rise—is that boat, and out on the many waters of the Sound Country, whether to sail or motor or paddle or pole about the tidal flats and creeks, it is and always has been worth far more than its weight or displacement in the best coin of our realm.

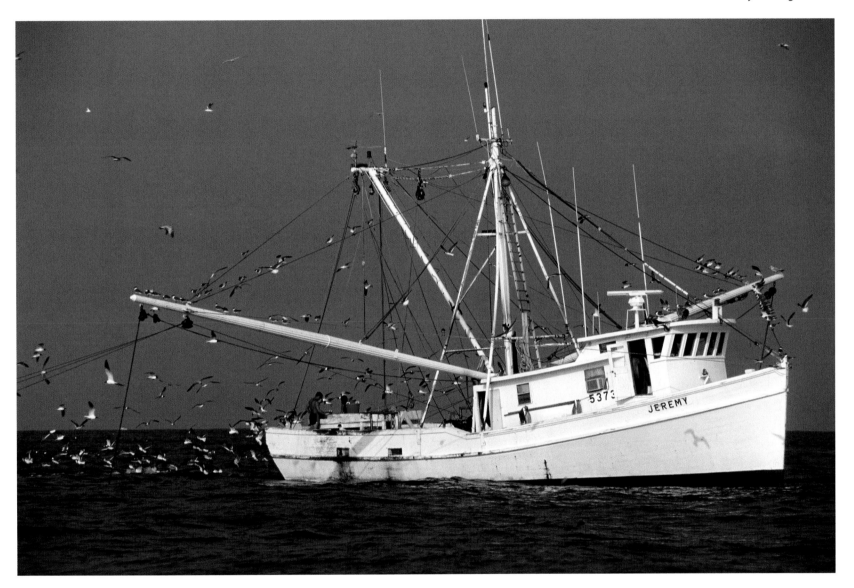

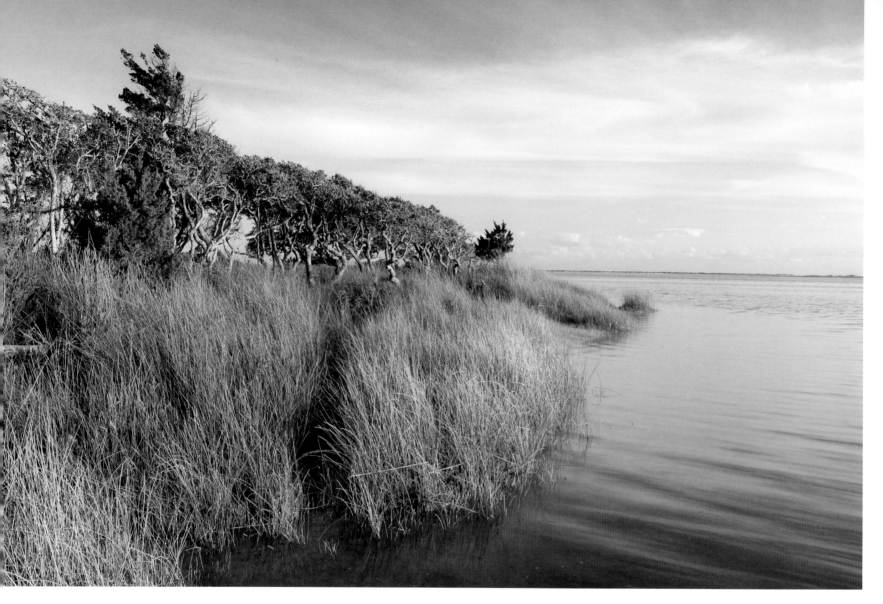

Carrot Island

I studied the slough's low green live-oak and myrtle fringe, the rooftops and chimneys and fish-plant smokestacks of the town beyond, mused upon our family's small place in this enormous maritime world, and felt thoroughly *at home*.

Frankie Salter Guthrie
at home, Harkers Island

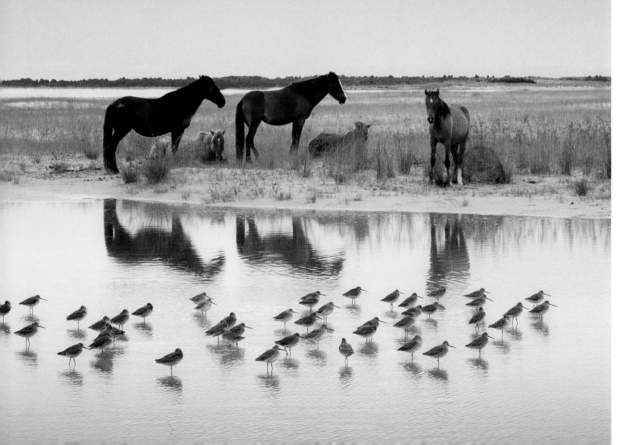

**Sand ponies and dowitchers on
Bird Shoal, Shackleford Banks beyond**

The shoal is a progger's paradise, an
unpopulated place to wander around
and through. Shorebirds are its leading
citizens—plovers, oystercatchers, willets,
sandpipers, dowitchers, and more. Peli-
cans fly low to the water, and porpoises
cavort near the sandbank shallows sea-
ward of the shoal.

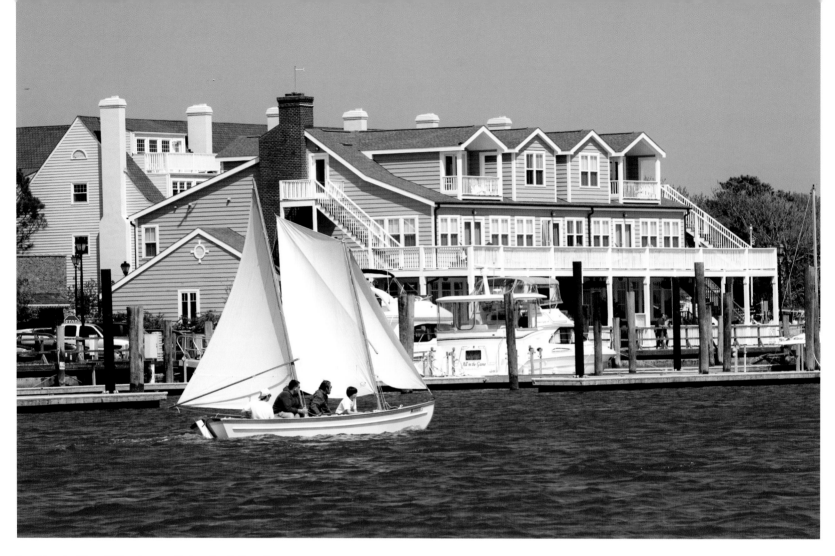

Traditional sailing skiff under way, Taylors Creek, Beaufort

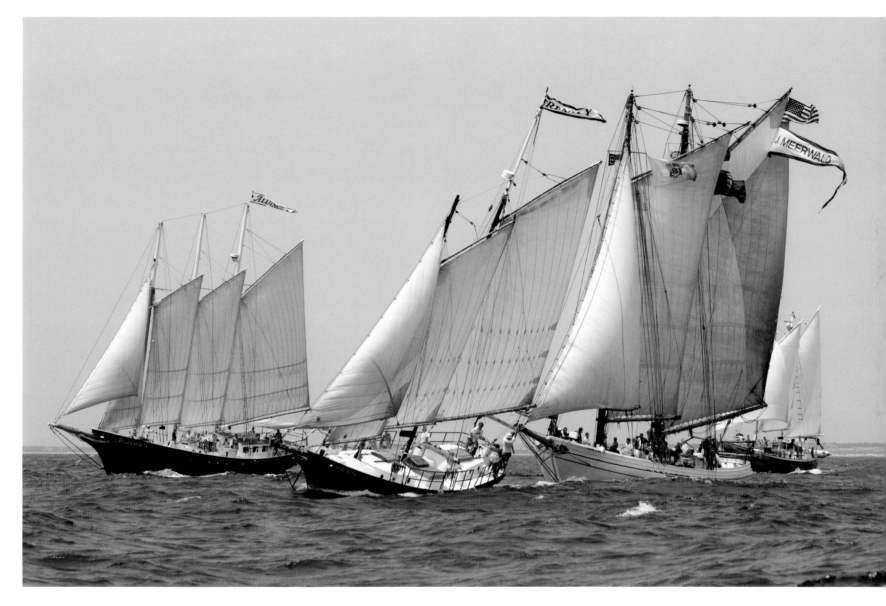

Tall ships racing, Atlantic Ocean off Atlantic Beach

For centuries the Carolina waters have by turns smiled upon and smitten many an acre of unfurled sail.

Meadows family in shallow waters of Deep Creek, Beaufort

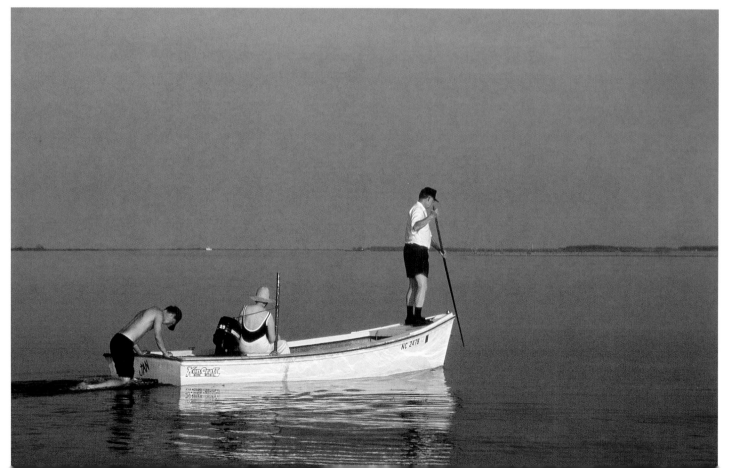

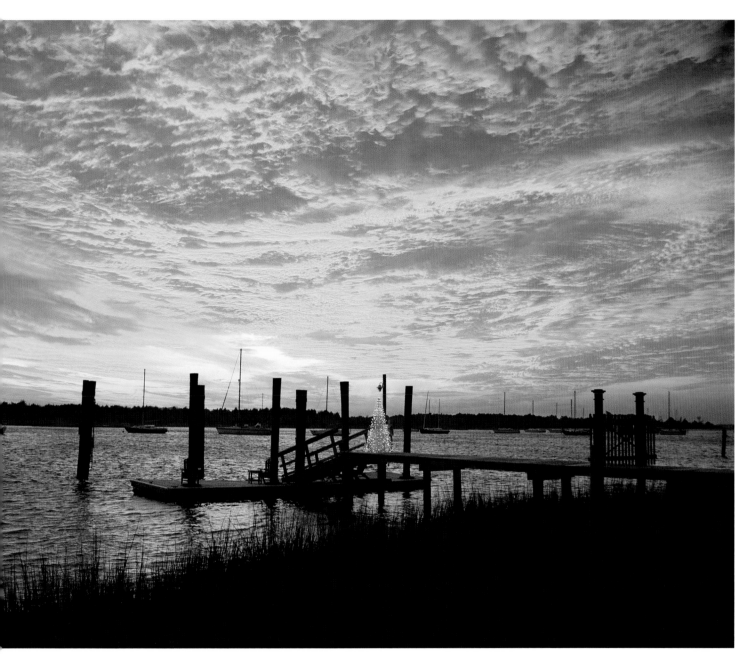

Winter sunset
at Taylors Creek,
Beaufort

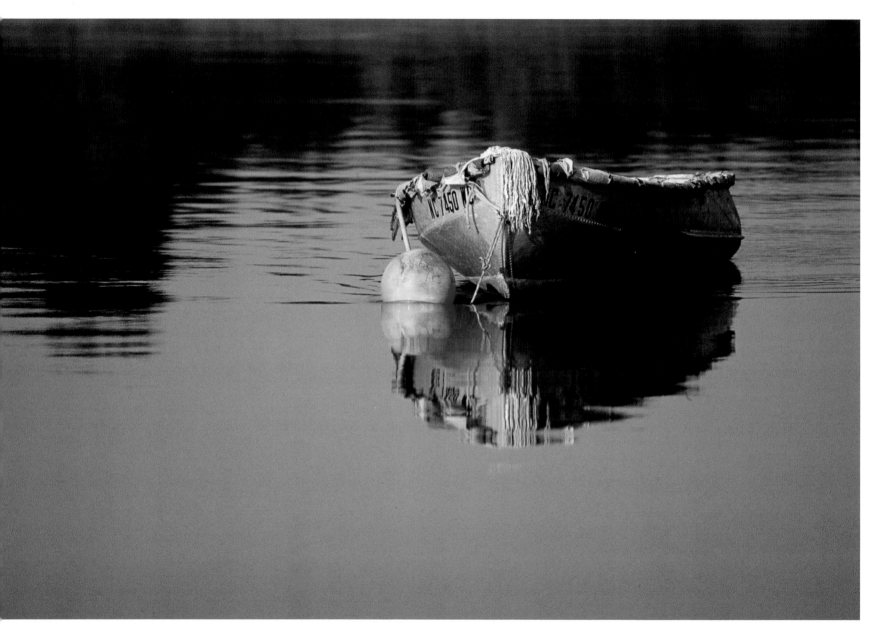

Tugboats and navy ship,
state port, Morehead City

Tugboat heading
to work, state port,
Morehead City

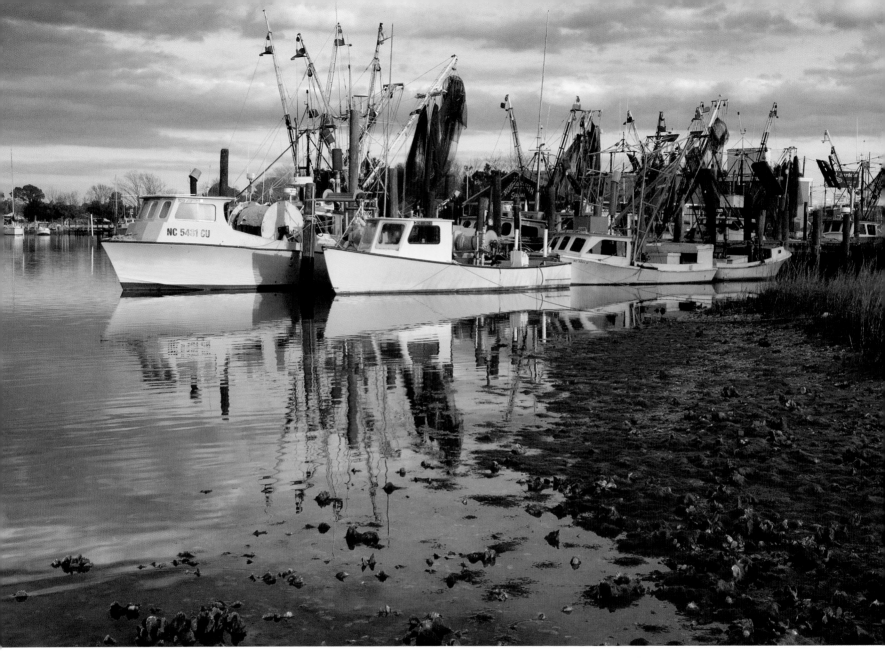

Small trawlers, Town Creek, Beaufort

The small fishing boats that appeared at our Water Street wharves in the afternoons, their holds full of the fruits of the sea, were said to have had a good day "down the Sound."

Old net reel at Beaufort Fisheries (closed), Taylors Creek, Beaufort

I came about and beached us across Taylors Creek just east of the menhaden plant, the astonishing wired- and braced-together batch of piping, boilers, conveyors, net reels, and tall thin smokestacks that has bought and paid for Beaufort, black and white, for generations.

Ottis' Fish Market (closed), Morehead City

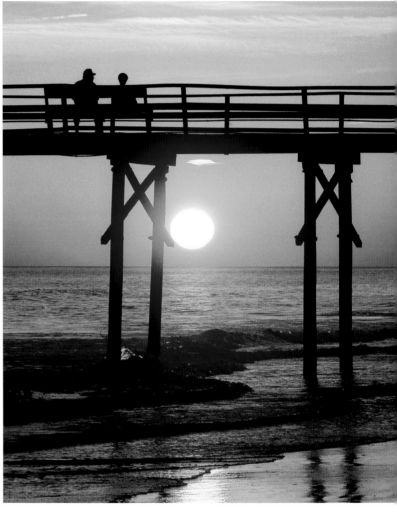

Oceanana Fishing Pier at sunset, Atlantic Beach

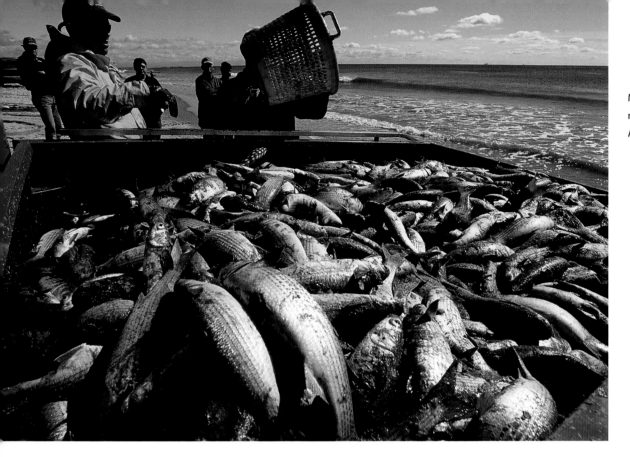

Men fishing for striped
mullet with stop nets,
Atlantic Beach

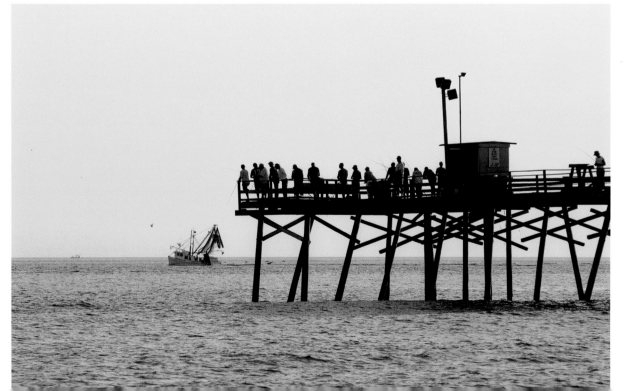

Fishing pier
and trawler,
Atlantic Beach

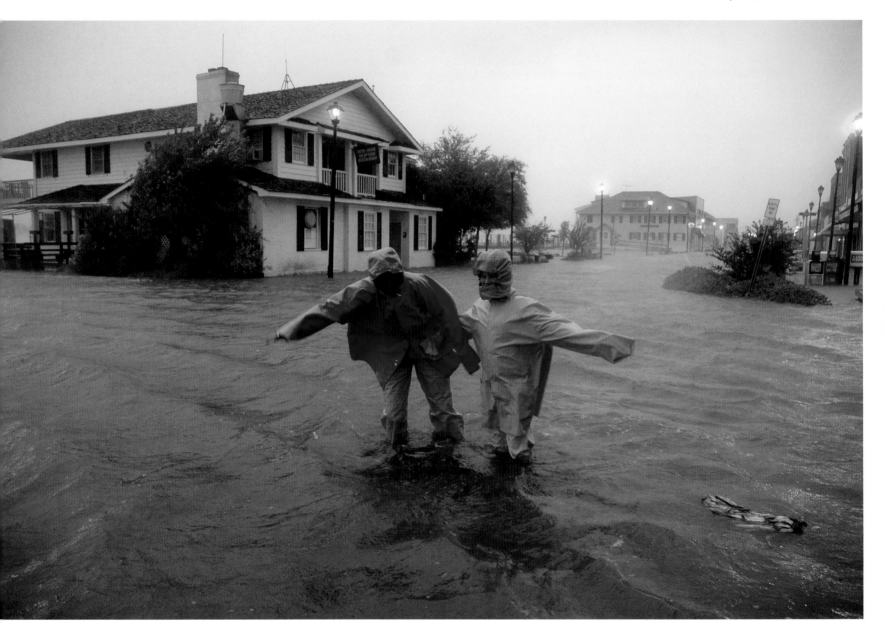

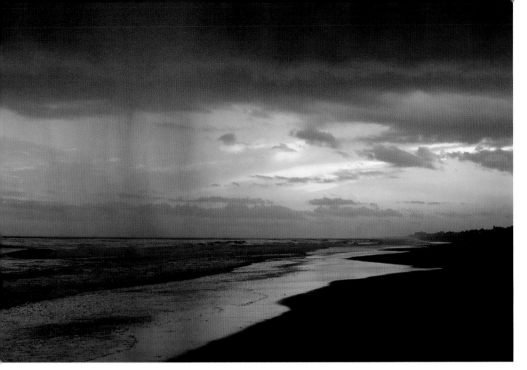

A spot of rain on
Bogue Banks

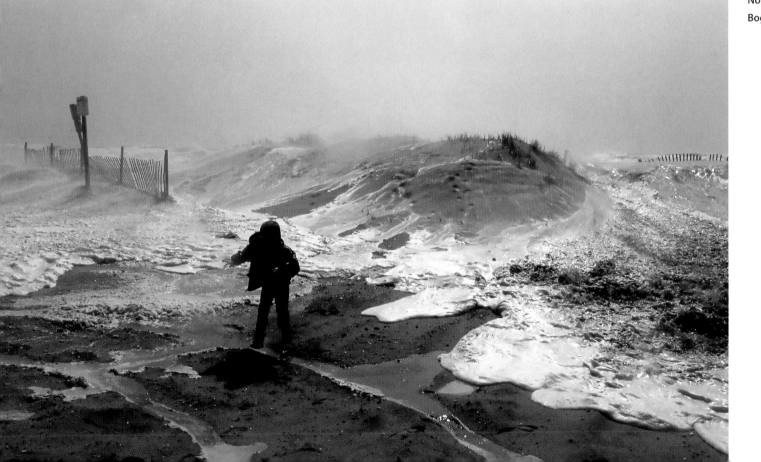

Nor'easter,
Bogue Banks

Bluefin tuna
fishing in the
Gulf Stream

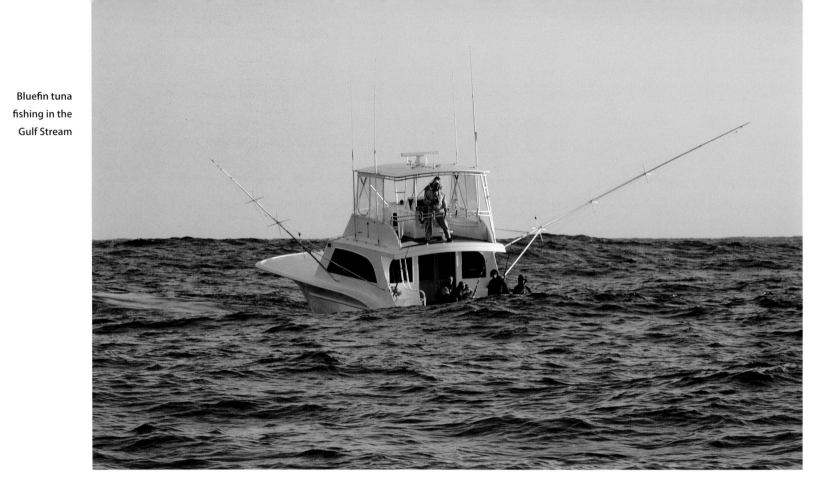

Heading to the Gulf Stream

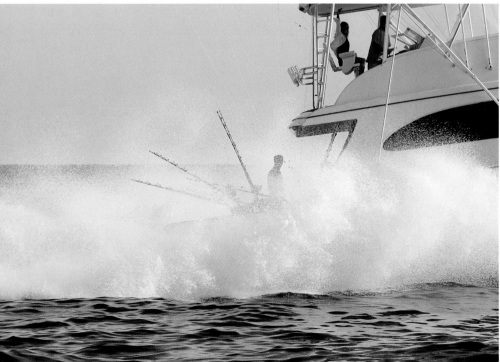

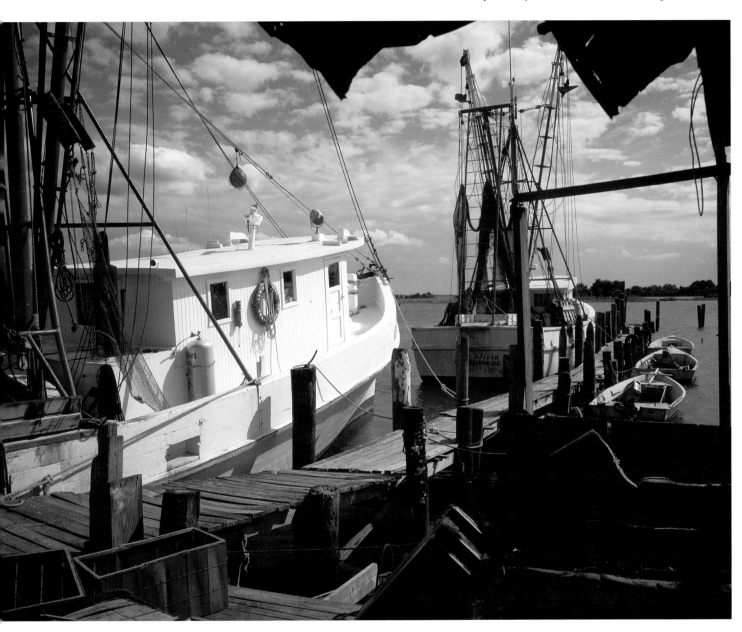

Trawlers, Clyde Phillips Seafood, between the bridges, Swansboro

121

Homer Smith's Seafood Market on Bogue Sound, Salter Path

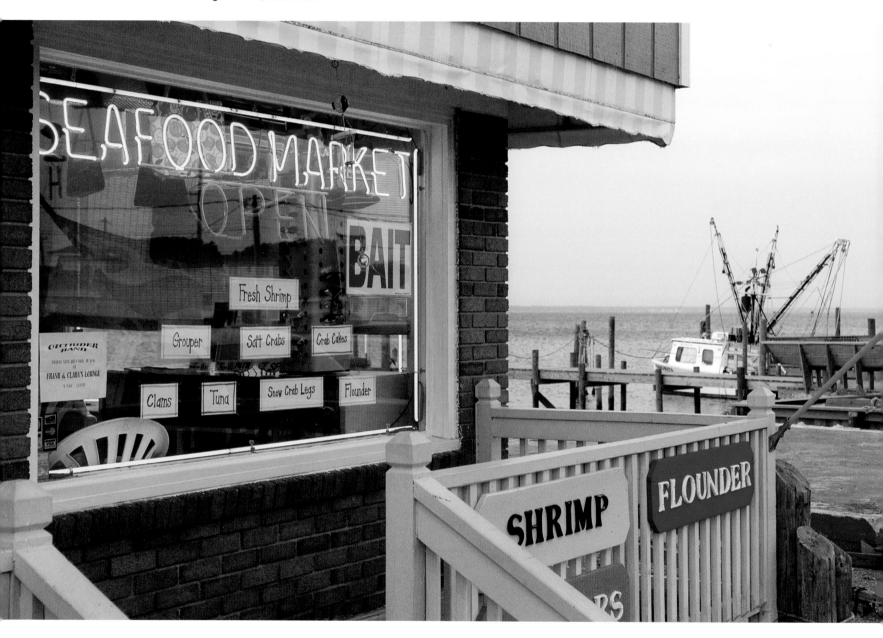

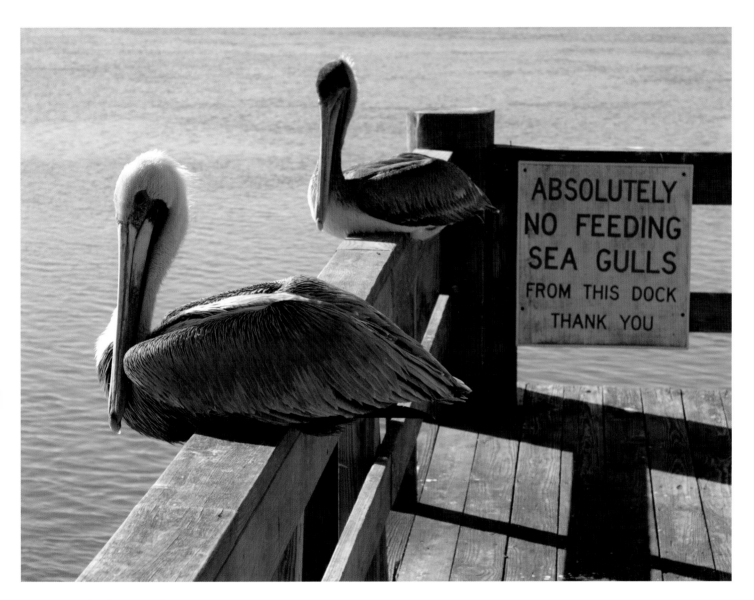

Pelicans, Morehead City waterfront

Rachel Carson would've reveled in the fact that, since the ban on DDT, pelicans have made a powerful comeback: an increase from 300 nesting pairs in the state of North Carolina in 1972 to about 4,000 pairs today.

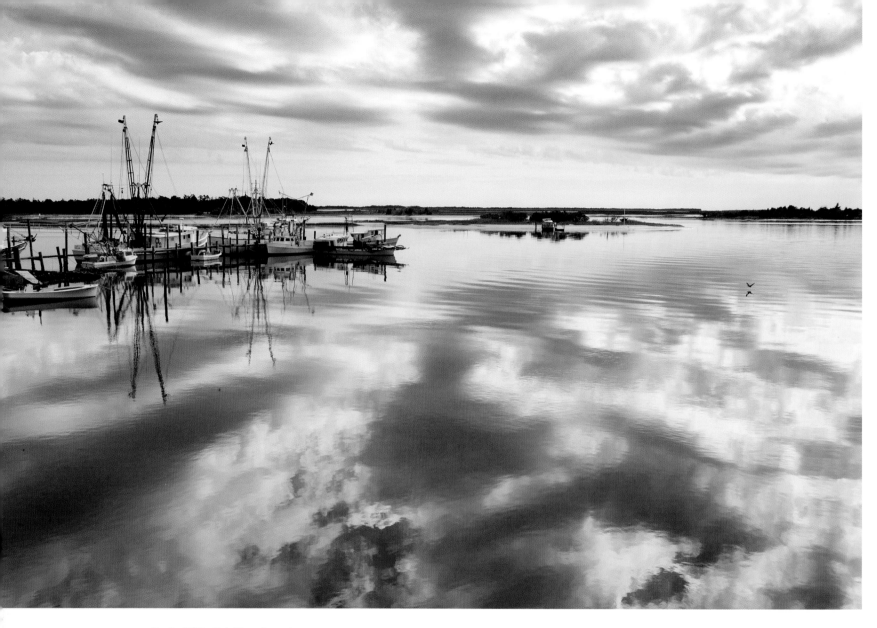

Docks, White Oak River, Swansboro

I'm taking you down to a home on the river
Taking you down to that great big old bay
Where nothing's forsaken, and all is forgiven
Oh, love of my life, I want to lead you astray.

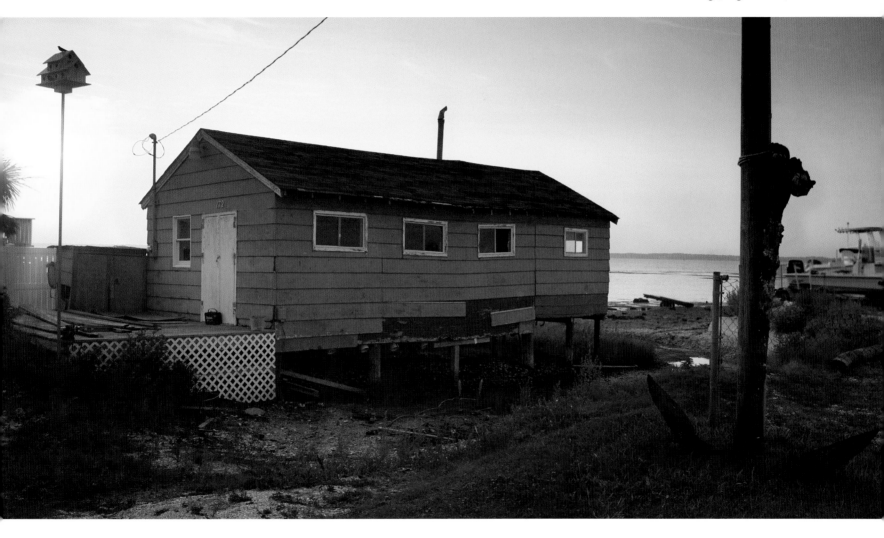

Don Weeks
shrimping on the
Newport River

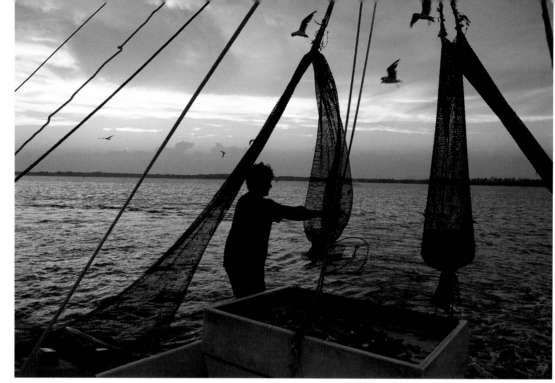

Don Weeks and his
catch, Newport River

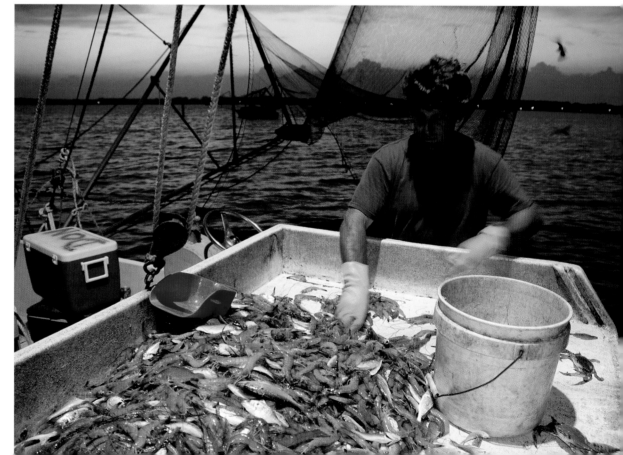

Cleaning fish at Camp Bryan

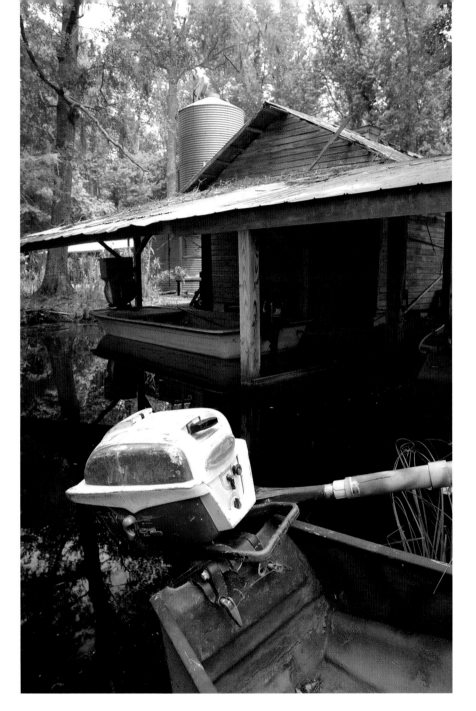

Boat shed at Camp Bryan, Lake Ellis Simon, Croatan National Forest

Canoeing on the White Oak River

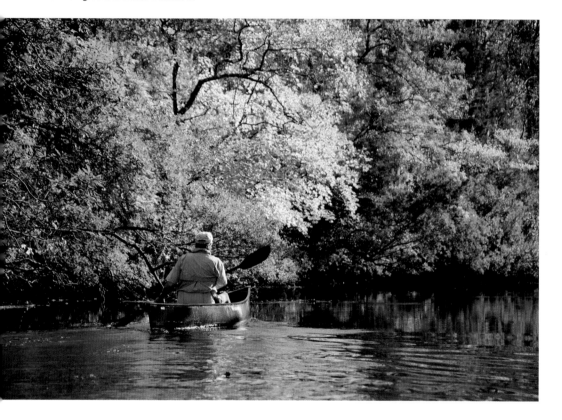

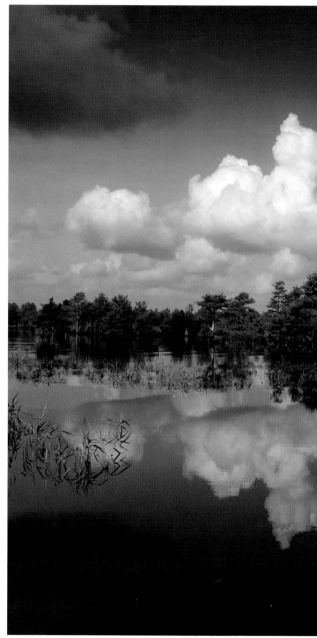

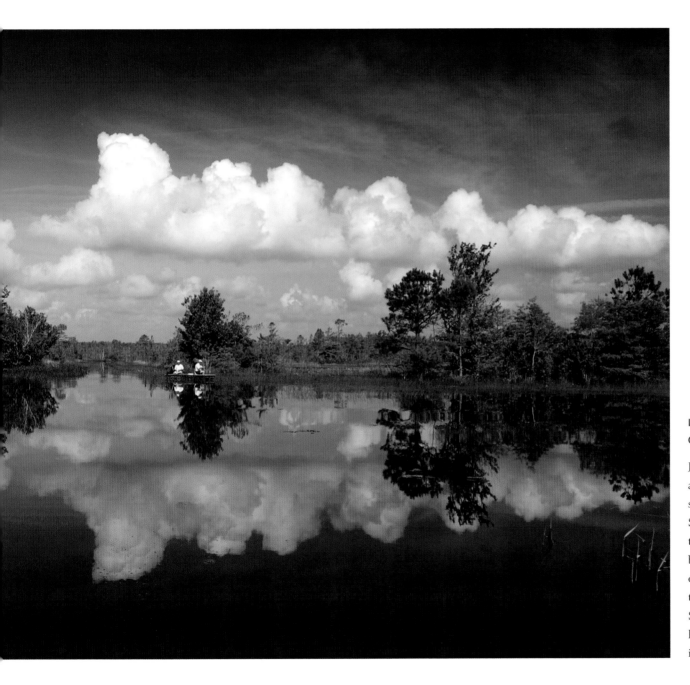

**Lake Ellis Simon,
Croatan National Forest**

Just through those woods were
alligators cruising Ellis Lake,
sometimes called Lake Ellis
Simon after the man who ran
the hunt club Camp Bryan
back here in the Croatan For-
est for so long, one more of
the formerly great number of
Sound Country waterfowling
hideaways that attracted and
interested many a man.

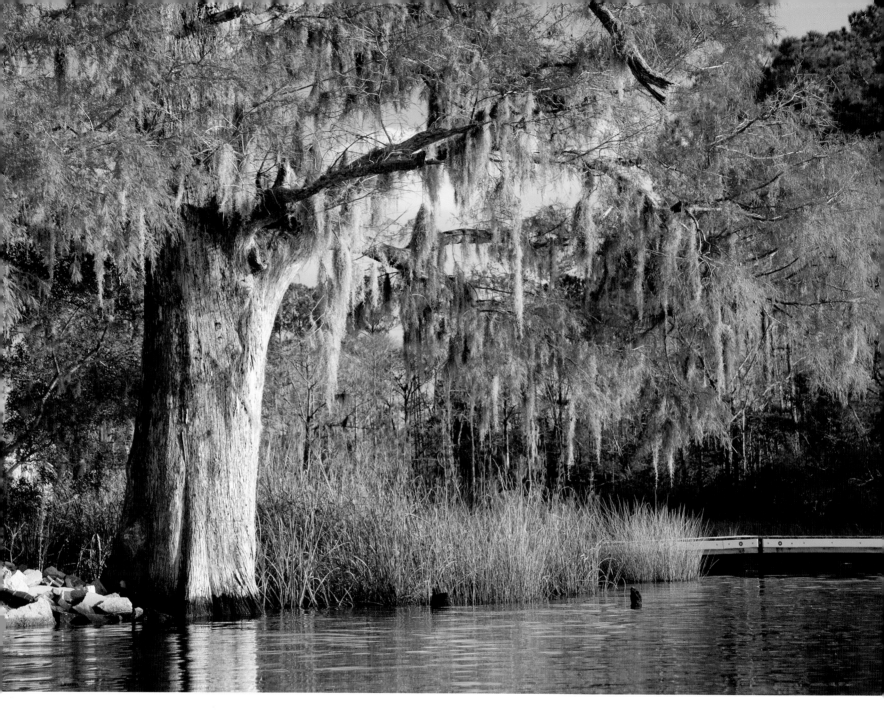

Cypress in fall, Broad Creek, near Minnesott Beach

Swamp forest, Broad Creek

Time and again I have gone back to Big Flatty, wandered and roamed the great forest that long ago ceased to seem strange and endless to me, and if I have found some small purchase on the way of the wilderness, it began there when I was still a small boy.

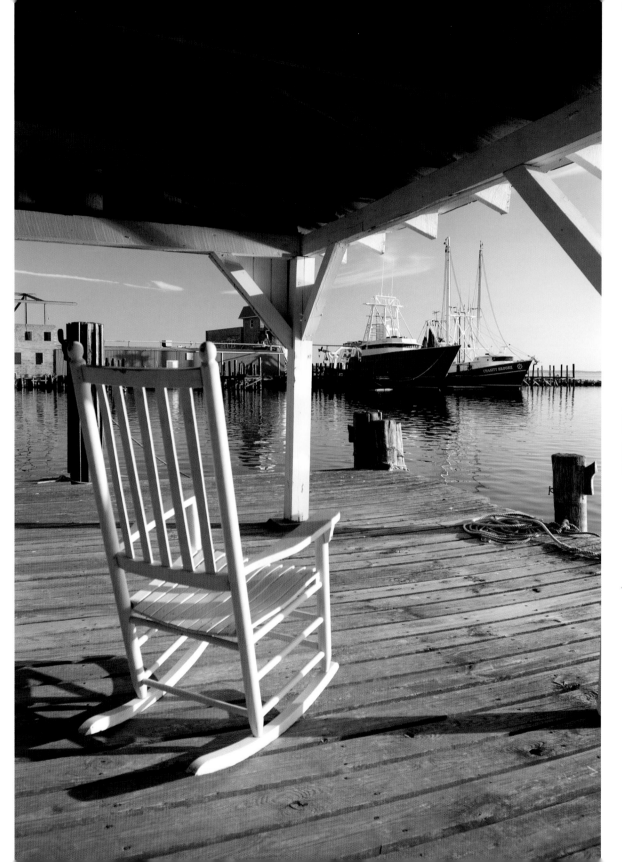

132

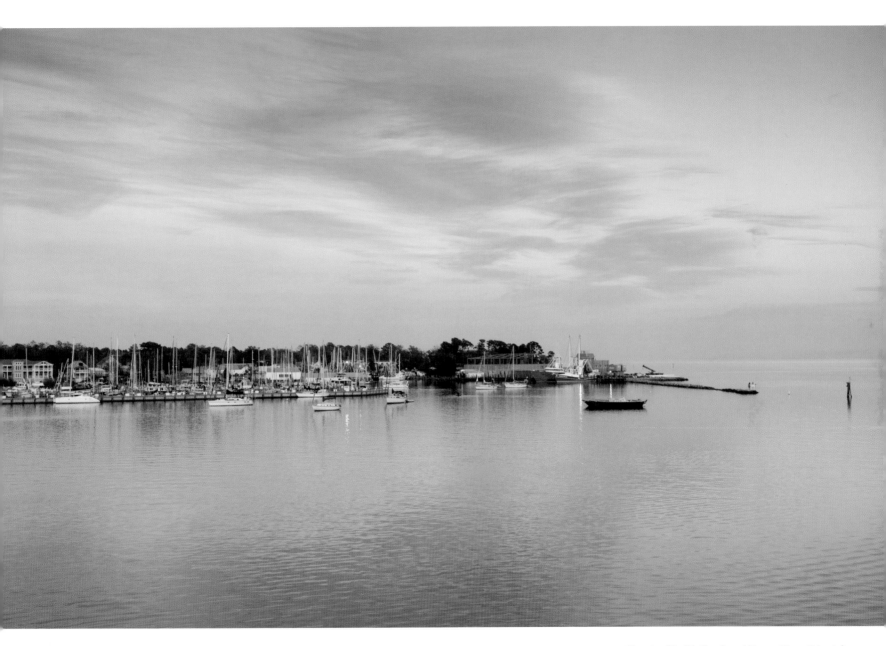

Mouth of Smith Creek and Neuse River, Oriental

Watermelons for sale outside of Richlands

Man walking home
outside of Richlands

134

**Derelict tug in Eagles Island shallows, across
the Cape Fear River from downtown Wilmington**

The Cape Fear River and its distributary the Brunswick made Eagles Island,
2,300 acres of marsh and swamp forest on the west bank of the Cape Fear,
across the river from downtown Wilmington. The great gray battleship *North
Carolina* now lay snug in its cut in the island's upper part, put there by the
pennies, nickels, and dimes of Tar Heel schoolchildren two generations ago,
and thousands of shorebirds in migration stop and seek shelter in the diked
dredge-spoil impoundments comprising Eagles's lower third. Little but the
tops of pilings at the river's edge give evidence of all the warehousing and
commerce that once went on over there, of the ferryboat *John Knox* daily
moving workmen and goods back and forth to and from such establishments
as the Dunn Brothers Company, whose riverfront wall once proclaimed its
interests to be "MOLASSES COFFEE RICE," or Frank A. Thompson's cooper-
age and shipping shed for "TAR, PITCH & TURPENTINE."

Old church graveyard in downtown Wilmington

Sit in a rocking chair on the front porch of a Fourth Street house in Wilmington and stare past the old church graveyard where the long dead sleep beneath the big live oaks, and look down the hill to the wharves where Market hits the Cape Fear River and know that when the greatest artillery display this continent has ever known fell upon Fort Fisher in January 1865 and collapsed it, Wilmington, the South's last open port, was finally closed to the world and the end of the Civil War was at hand.

Thalian Hall, built 1855–58, Wilmington

I had just played piano around the corner at Thalian Hall, behind whose chalk-white columned portico was a velveted and balconied jewel-box of a theater, and the gracious reward beyond the honor of the thing and the paycheck of it too was these few moments of looking off through space and time from a side street of what for two centuries anyway was our state's greatest port and city. A couple of years earlier, after another night on the Thalian boards, our crowd had gone out for a while into the bright, cheerful, agreeable din of the Café Phoenix down on First Street, with its faux marble and narrow balcony and Italian-sausage-and-capers sandwiches, a hot Bohemian draw specializing in a meld of theater and film and rhythm-and-blues society.

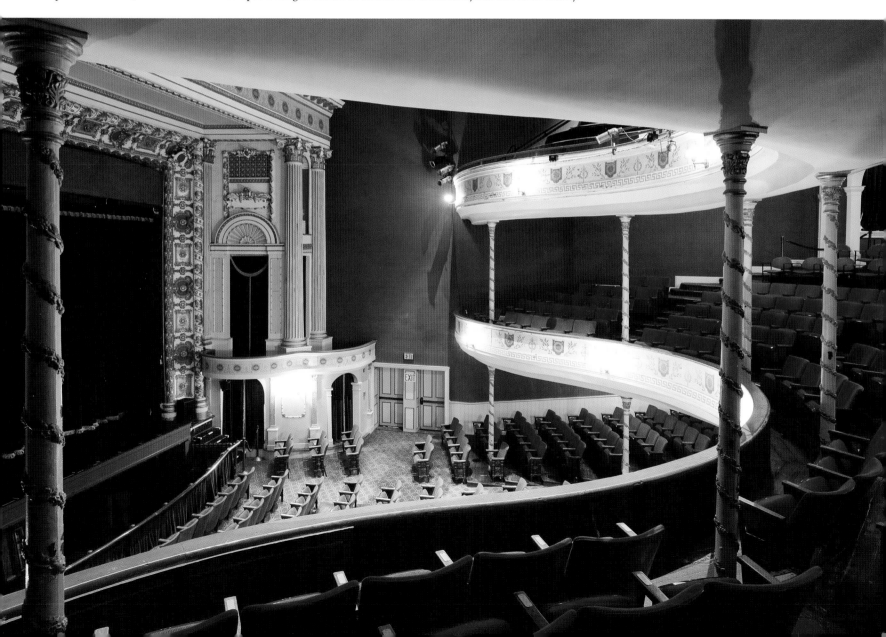

John McNeill on
his dock, Lake
Waccamaw

John McNeill's dock,
Lake Waccamaw

138

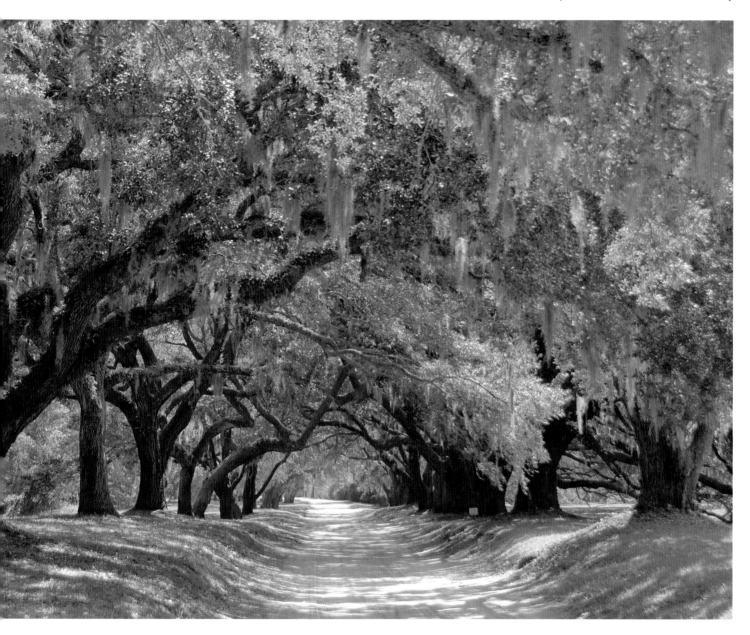

Live-oak alley, Orton Plantation, Brunswick County

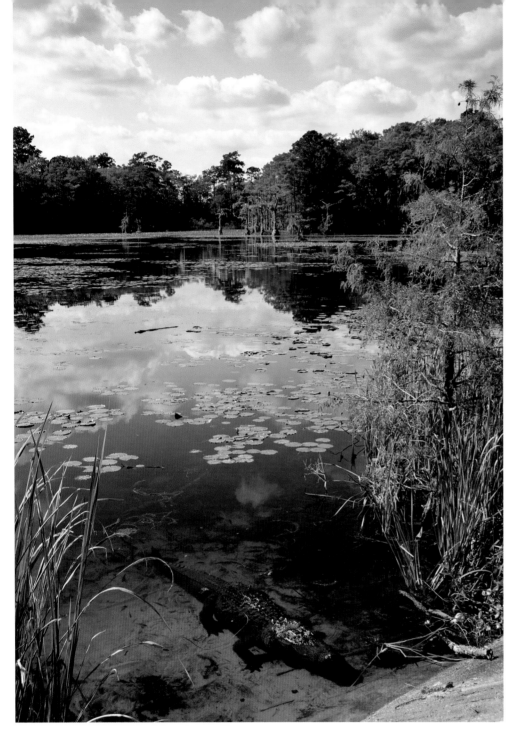

Orton Pond

There are so many coastal places I am still only beginning to get to know; I have yet to crawl over them dozens of times, as I have Bird Shoal. We all of us have such places, and we all know that the steady accretion of meaning—through repeated visits, sojourns, stops, landings, ambles—downright takes a while. In the human world, such things as violence and unkindness *do* reveal themselves all at once; but in the natural realm, woods and fields and waters, however they appear at the moment, are always suggesting what they will be next, once the moment or the day or the season or the wind or the light changes, and suggesting further that one must return to the same place again and again if one would see into the heart of its matter, or even come close.

Acknowledgments

BLAND SIMPSON expresses a deep gratitude to all those who have helped and guided him through coastal Carolina over many years, and he gratefully acknowledges the support of the Institute for the Arts and Humanities, the Bowman and Gordon Gray Distinguished Professorship Program, the Creative Writing Program and the Department of English and Comparative Literature, and the College of Arts and Sciences, all at his alma mater and longtime home, the University of North Carolina at Chapel Hill.

SCOTT TAYLOR gratefully acknowledges the help and support of the many people who offered their time, hospitality, local knowledge, and many and varied boats, from twelve-foot kayaks to sixty-foot custom Carolina fishing machines, and says: "Thank you for getting me there." To Keith Rittmaster and Cape Lookout Field Studies, a program of the North Carolina Maritime Museum, Scott offers a special thanks for allowing him to share his love of image-making with others.